London
Tattoos

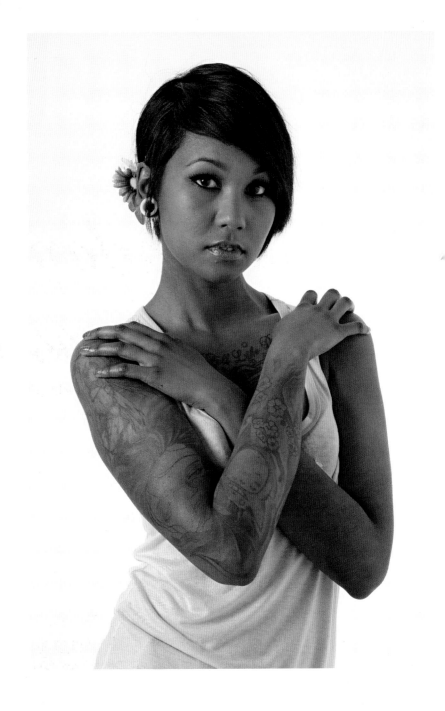

London Tattoos

Alex MacNaughton

PRESTEL

Munich · London · New York

Contents

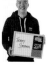
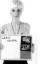
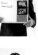
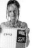
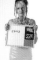

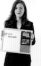

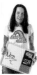

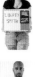
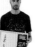

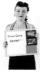

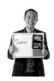
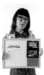

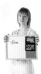

224

Coral Davies

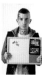

230

Justin O'Grady

238

Alex Harvey

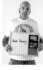

246

Lod

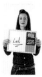

252

Graham Long

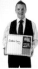

256

Cara Fielder

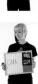

262

Miss Belinda

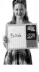

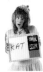

266

Laylay

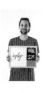

270

Kat Williams

276

Stewart O'Callaghan

280

Heather Holyoak

288

Scott Pollard

292

Louise Elizabeth Fury

298

Mistress Jezabel

Foreword

by Dr Matt Lodder, University of Reading

The history of tattooing in London is long, and proud. The first tattoo shop in London was opened near Holloway prison in 1870 by a tattooer called David W. Purdy, and from the very beginning London served as a cradle for the brightest and best that the art form could offer, the rich tapestry of the vibrant city feeding an innovative, skilful and ornate craft. As if to repay the city some small amount of all it had given him, Purdy suggested to his clients in a pamphlet he published towards the end of the 19th century designs which included 'Tower Bridge ... the Great Wheel, at Earl's Court, or the Imperial Institute, or one of Her Majesty's Battleships, and the Houses of Parliament, all making good pictures, which could easily be printed neatly on flesh'.

By the 1880s, driven by a trend led by the dandyish Prince Bertie (later to become King Edward VI), tattooing was all the rage amongst the most fashionable of London's high society. On the refined and rarefied Jermyn Street in the West End, the famous Victorian tattooist Sutherland Macdonald ran a luxurious and lushly appointed studio, replete with cushions and gilded divans. In Waterloo his contemporary, George Burchett, was making a handsome living tattooing aristocrats and officers, and decorating the ankles and shoulders of the most elegant of ladies. Stories abound of wealthy barons at the end of the 19th century spending dozens of guineas on acquiring tattoos from the most in-demand of artists, and of trends in motif and style emanating from London's tattoo scene causing admiring chatter around the world.

Not much has changed in the intervening century or so. The people, stories and tattoos Alex MacNaughton has documented for this book are part of this unbroken tradition of fine tattooing in this most eclectic of cities. From professionals to punks and from pharmacists to photographers, the tattoo collectors shown here represent the vast diversity that has always been present amongst London's tattooed.

Some of the tattoos his subjects bear are large, intricate and complex collaborative creations which will have taken dozens of hours and hundreds of pounds to complete. Others are smaller, whimsical, spontaneous. Some may be regretted, most are warmly cherished. Several of those whose images fill these pages are heavily tattooed, steeped in the culture, history and mystery of tattooing. Others have only a few tattoos, discrete and subtle. Yet all are united by the decision they have taken to donate their own skin to an artist for the creation of an image.

As in the Victorian era, London's tattoo scene today is looked upon admiringly from all over the world as a hotbed of talent and innovation. Whether their tattoos are decorative, demonstrative or decadent, every single person featured in this compendium of tattooing in 21st-century London has given their skin to this art form. In a city famed for being a bubbling cultural cauldron, it is hardly surprising that the simple process of marking the skin with ink produces such great variety, quality and sheer boldness of work.

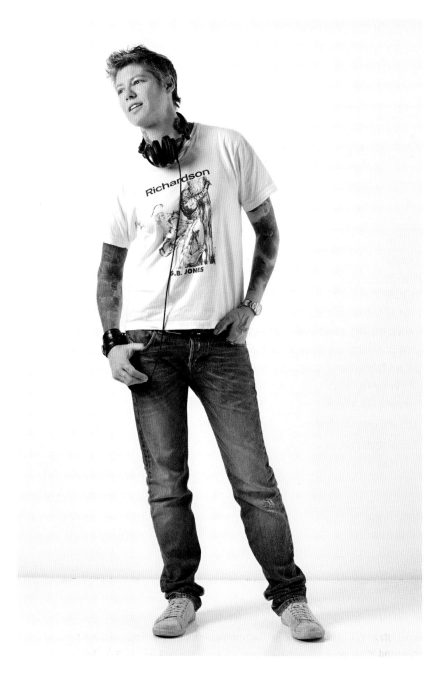

Alice Temple

Age: 43

I have a few home-made tattoos. One was done by Rachel Williams: it's an arrow going down my butt-crack. I have scat written on my right forearm: this was done by Tony Ward. My tattoos don't mean any thing to me other than I like being covered in tattoos. It's purely a visual thing. I like the look of almost anyone who is covered, and knew I wanted the same. What I have on me is almost irrelevant. What is important is the artist who works on me. I'm very lucky and privileged to have Nikole Lowe as my tattooist. I basically let her do what she wants. Who knows what my next tattoo will be. I've got my legs and stomach to start on. I'm pretty sure I want Nikole to do her beautiful flowers all over my legs, but there are other bits and pieces I want. It kind of depends on how rich I am at the time. Nikole is going to do my left-hand knuckles with wood instead of needles, Japanese style — probably the four suits of a pack of cards.

Head, left and right neck, left and right biceps, left and right forearms, chest, upper and lower back Nikole Lowe | **Left hand** Mr X | **Left calf** Self-tattooed

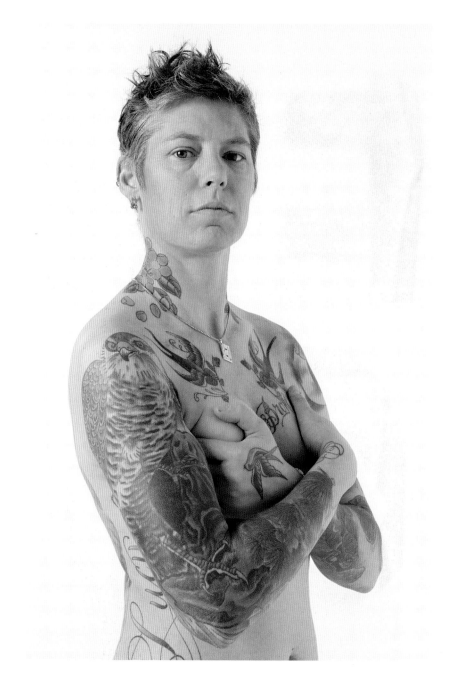

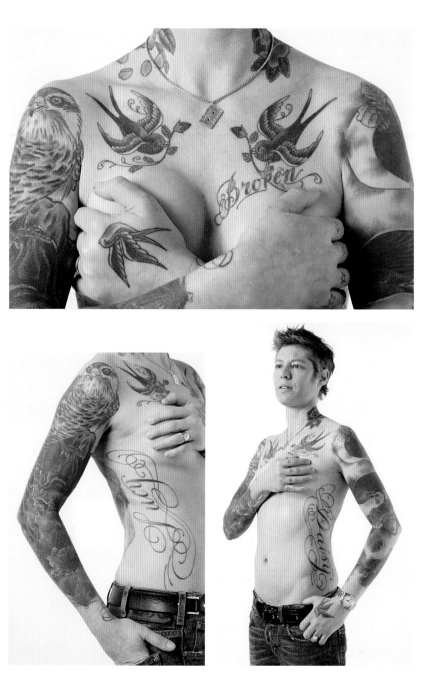

14

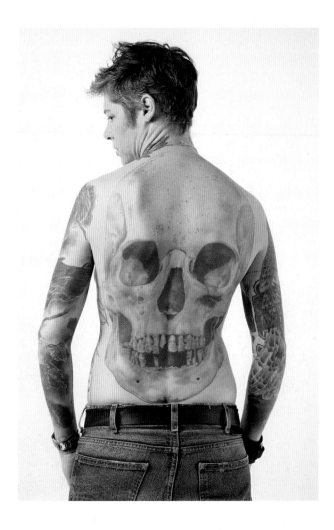

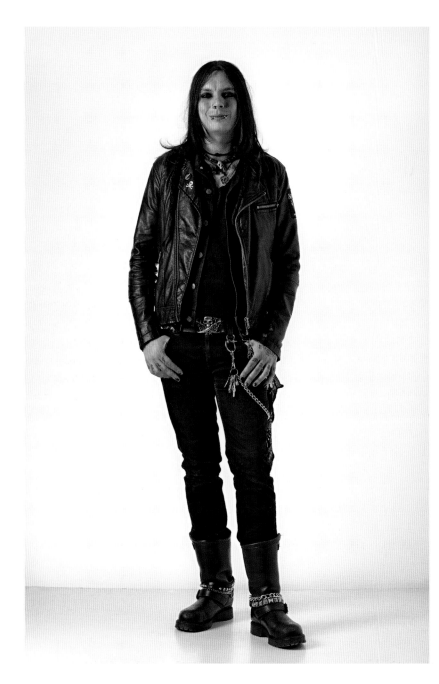

Arnö Vön Detritus

Age: 31

Tattoos are for me a way of expression, a constant reminder of good and bad times I went through. I see my body as a book where the tattoos are there to document different times and stories of my life. That's why I don't think I will ever get anything covered, as even if the older tatts look pretty cheap and badly done by my standards nowadays, at some point in my life they meant a lot and represented something for me. I also use tattoos as a reminder of not making the same mistake again. And finally I see them as a way of distancing me from 'the rest', an immediate identification to another part of society, making clear to people that I am not 'like them', even if this sounds like a cliché. They are something you have suffered for, and earned, something that doesn't come 'cheap', and something that can't be taken from you. In the future I'm planning loads! The more the better. The next few projects are NOMADIC above my belly button, as I don't feel attached to any part of any country, and feel like where I lay my head is home. No strings attached. The skull of an ARIES, as my star sign is Aries, and I think it defines pretty much my character — creative, stubborn and impulsive. And, of course, finishing my sleeves and second hand with more skulls and demons.

Left bicep, left hand Greg Bilko | **Right bicep and forearm, chest** Alexandre Mansuy

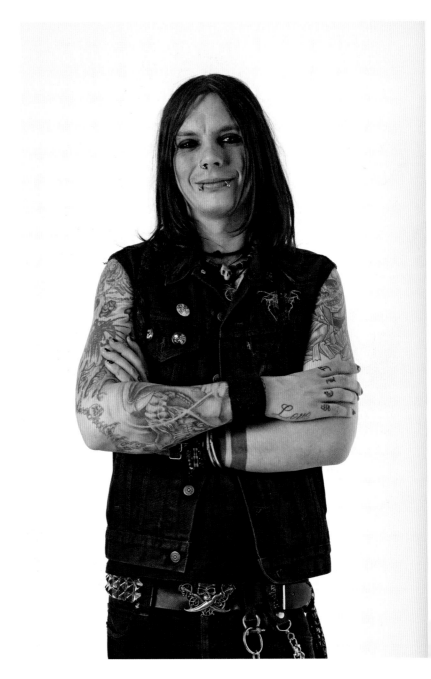

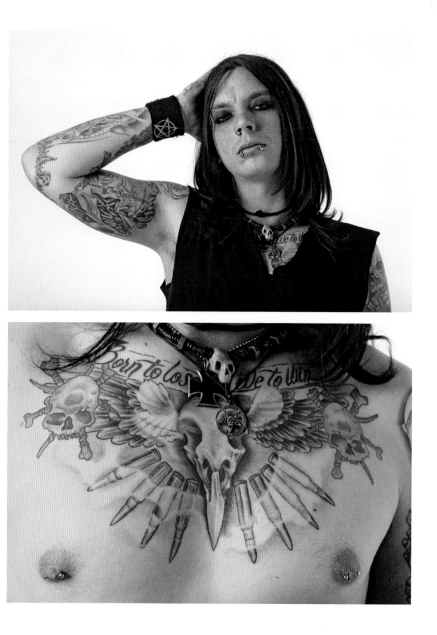

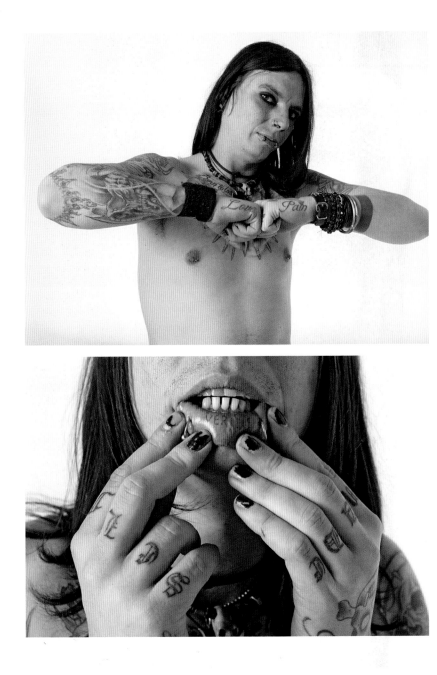

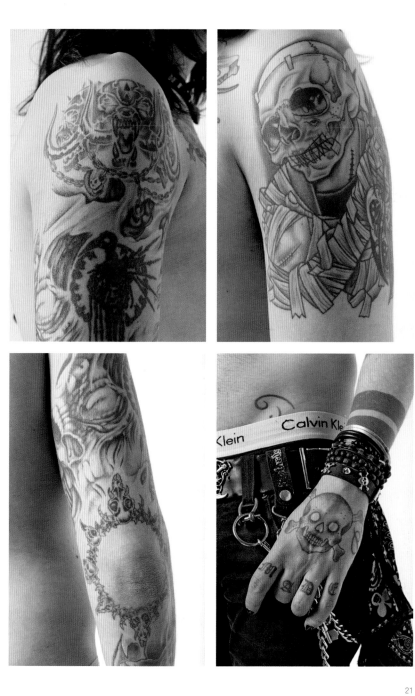

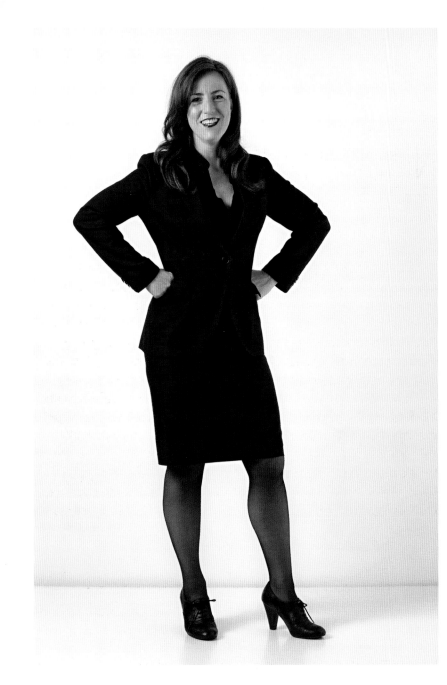

Nicola Redford

Age: 35

To me tattoos are a wonderful part of self-expression. I love the idea that I can decorate my body with what I see as art in tattoo form. Unlike many people my tattoos don't signify or commemorate any specific people, or incidents in my life, but are basically bits of imagery or wording that I find beautiful or have resonance. They are, however, intrinsically a part of me; they are part of who I am, an outward expression of an inner sentiment. They are a political/social statement of sorts as much as a whimsical penchant for the aesthetically pleasing. I could absolutely tell you exactly where and when I was when each one was etched on, so in many ways they form a timeline whereby I can plot my journey through life in all senses of the word. I have another session coming up in August to work on my arm piece. Not planning to add a huge amount more to it at the moment, but just tweaking few bits and having some more detail put in. After that, who knows? I think the arm piece will get extended a bit more so it becomes a ¾ sleeve, but haven't decided what I want to continue it with image-wise as yet, so it's still a work in progress.

Left bicep Remis at Tattoo Prime | **Stomach** David at Barry Louvaine

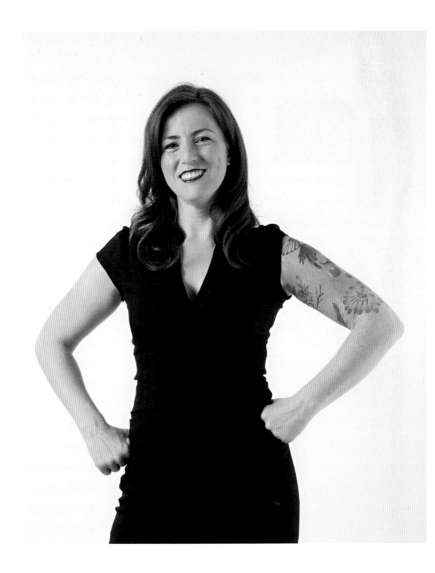

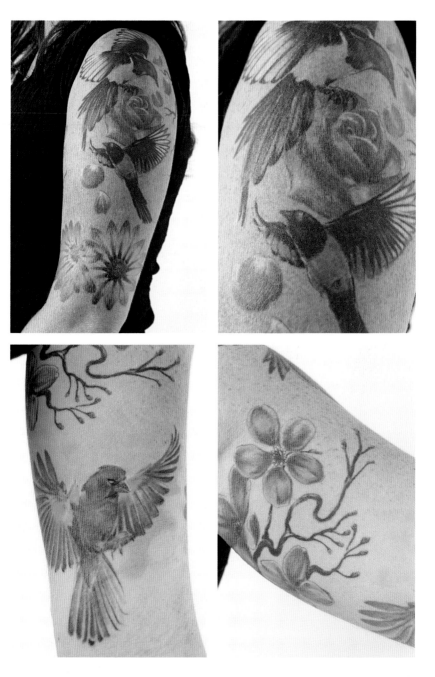

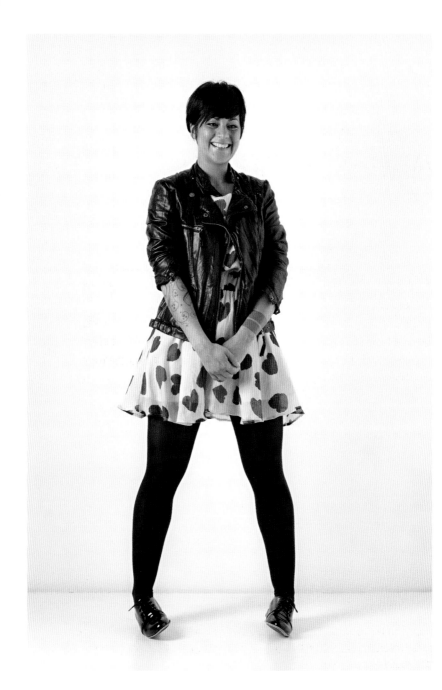

Angelica Araujo

Age: 32

Some of my tattoos mean different stages and important moments of my life. (It's more like memories: some people take photos, make videos, I do tattoos.) It's very difficult to explain because it doesn't mean anything to anyone — like my red stripes mean 'London' because it was the time I moved here. I just want to remember that when I get older. I haven't decided on the next design yet, but I know it will be something very feminine and will be on my legs. But I need to wait for the right time.

Most of my tattoos are from Brazil. The red stripes I did in London. I remember one guy named Eduardo from Brazil did the big tattoo on my right arm. The others — I don't remember their names anymore.

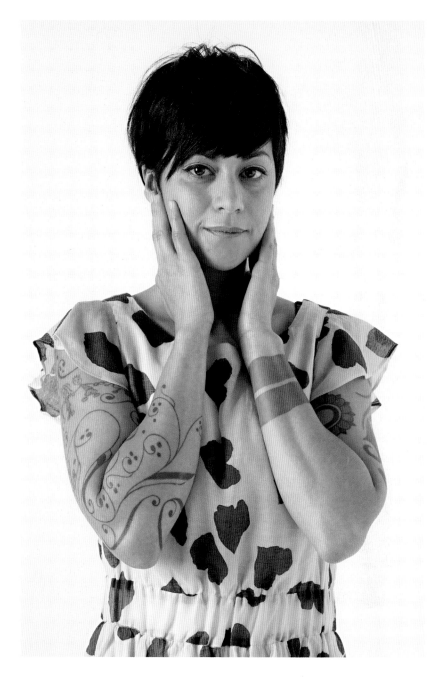

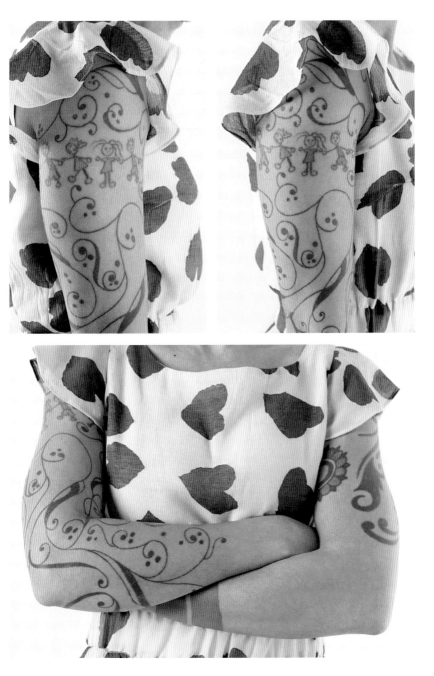

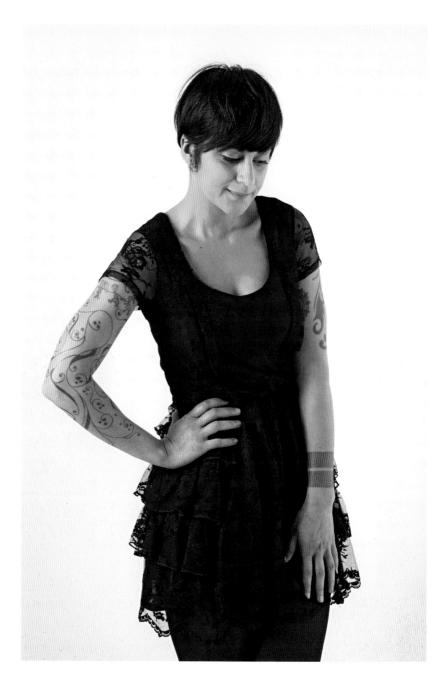

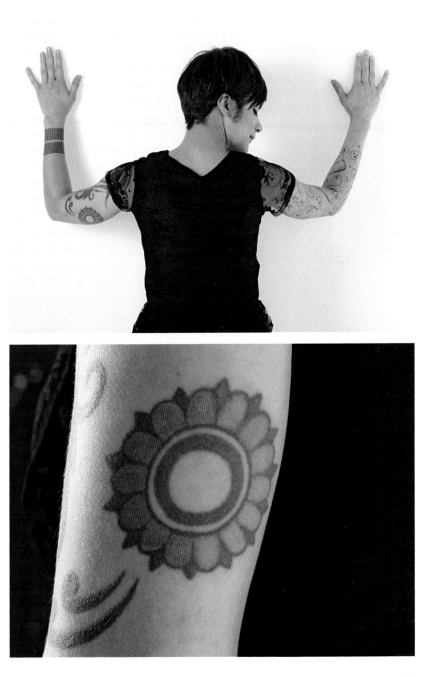

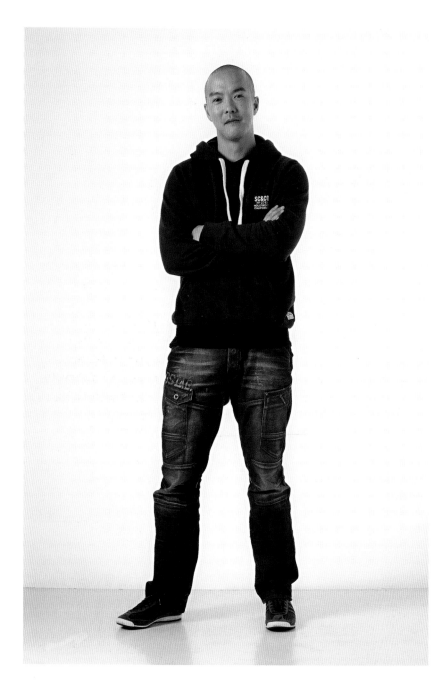

Terry Stephen

Age: 38

Right arm and right chest: the dragon represents the birth of my beautiful daughter Jasmine, born in 2000, the year of the dragon. Back: the heavens and the sea/earth meeting, blessed by Guanyin (the Buddhist goddess of compassion). Left lower back: Chinese characters which roughly translate as 'There is no right or wrong in this life, only the choices you make'. Left lower front abdomen: Koi carp — a symbol of aspiration, perseverance in adversity and strength in purpose. Related to the legend in which, if the Koi succeeded in climbing the falls at a point on the Yellow River called Dragon Gate, it would be transformed into a dragon. My next tattoo — maybe a rabbit under the wings of a phoenix. This will represent my next child.

All designs and work were done by Jimmy, a Vietnamese tattoo artist who had a studio in his sister's hairdresser's shop in Dalston. No idea what his surname is; he's a friend of a friend. He said that he was a juvenile delinquent and while in prison was taught the art of tattoo. After his release, he found a vocation and a new path.

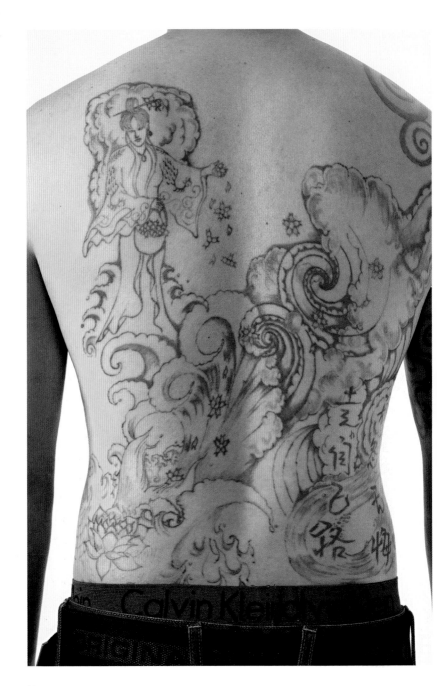

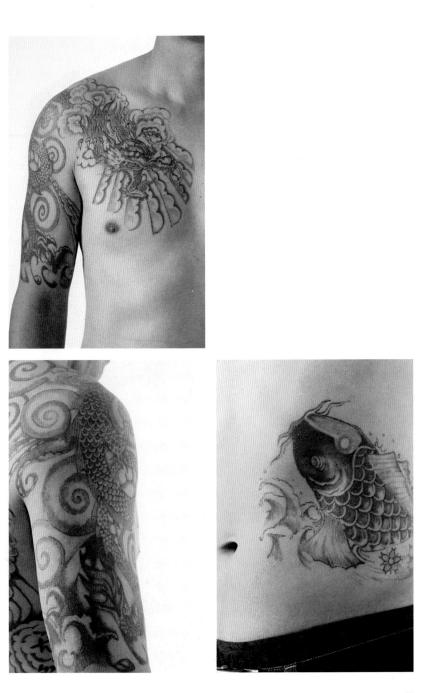

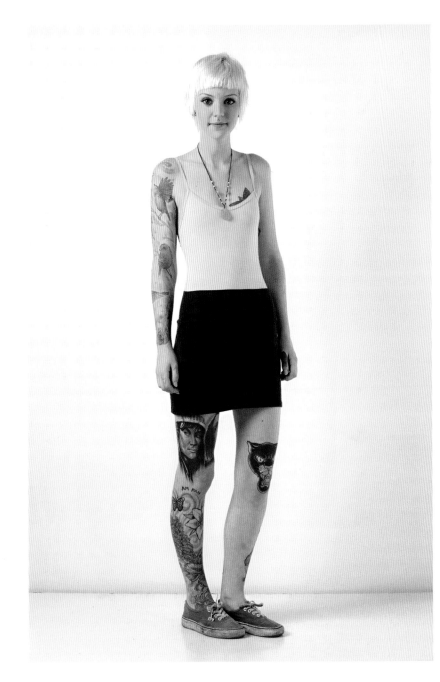

Grace Neutral

Age: 22

My tattoos mean everything to me: each one holds a memory of
a process I have been through with people I am close to, and artists
I admire. Each one has helped me in my journey into feeling more
complete. My next tattoo will be the back of my neck by my friend Tutti.

Right bicep and forearm, left calf, right foot Matthew James | **Left and right
hands** Danny Kelly | **Chest** Xed Le Head | **Stomach** Tamara Alesworth. Xed Le Head.
Matty Dearienzo | **Lower back** Piotrek | **Left thigh** Francisco Rocha. Kiko Lopez |
Right thigh Joao Bosco. Piotrek. Nick Whybrow | **Right calf** Matthew James.
Neil Pengilley

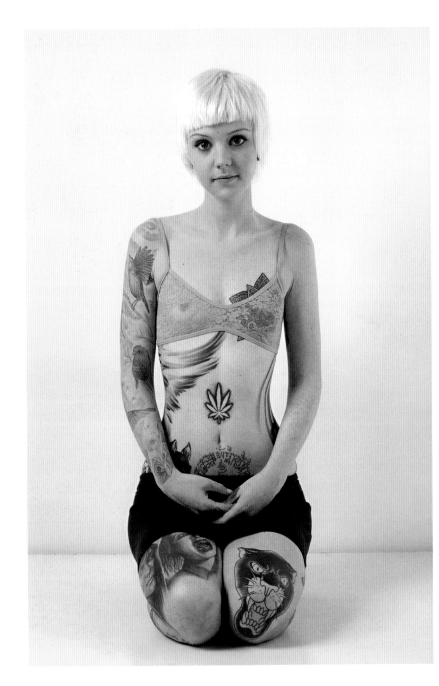

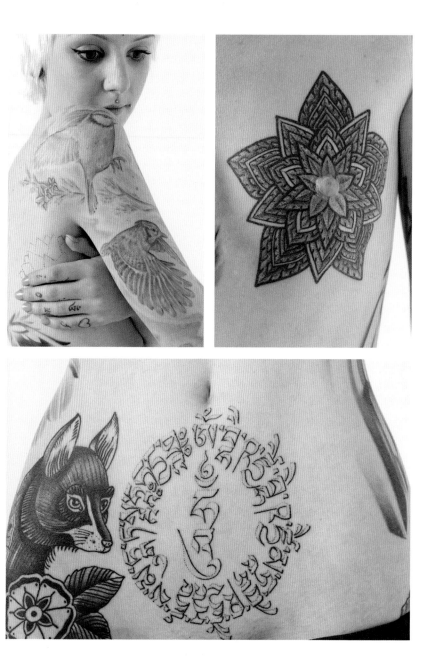

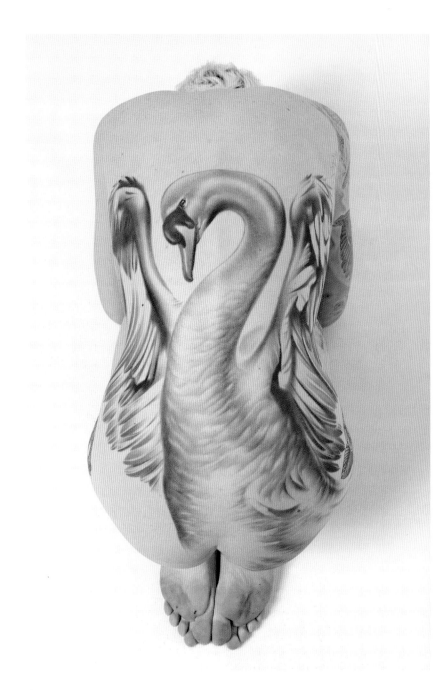

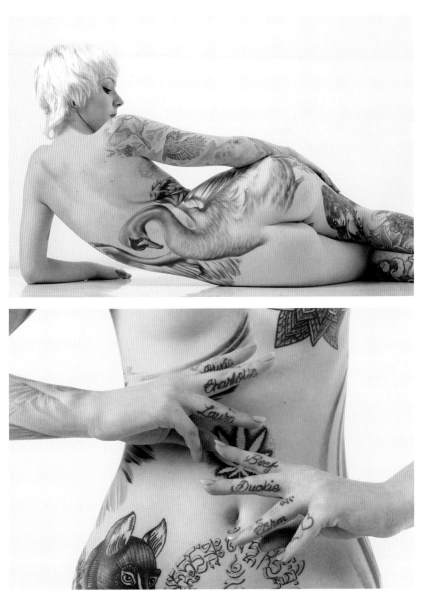

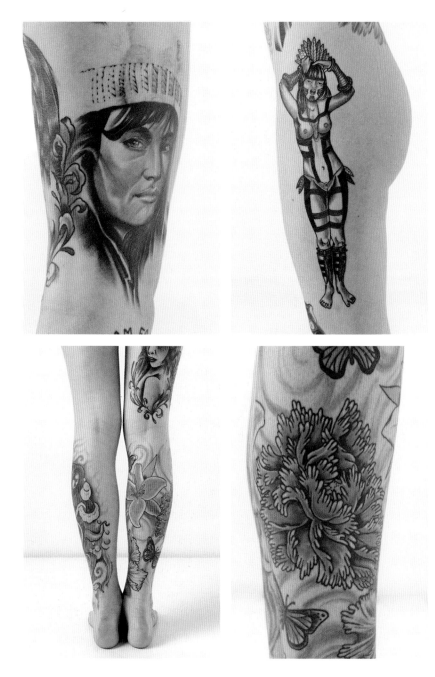

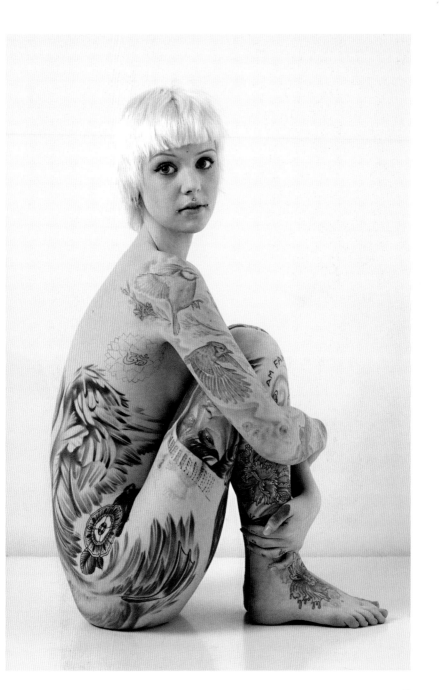

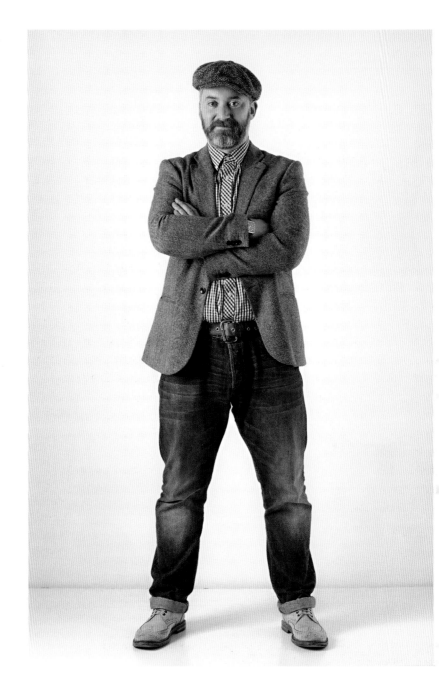

Dylan Ross

Age: 40

My first tattoo was when I was 20 in Kensington Market: it's a blob now, but I'll never get rid of it! I have been tattooed by Nikole Lowe at Good Times for the last ten years. The last tattoo was my diamond behind the right ear by Danny Kelly, who I've known since he was an apprentice, back when I first got tattooed by Nikole in Frith Street. I'm not finished yet, much to my girlfriend's worry! Ah, that eternal question… 'What do your tattoos mean to you?' They represent my life, in particular my daughters. They are my way, short of standing on a soap box at Speaker's Corner, of letting the world know who I am and why I am! Deep I know, but you did ask! But, away from all the deepness, they look great. I am in awe of the art form and couldn't have asked for a better artist than Nikole Lowe to express those feelings for me. My next tattoos will be an old school image of craps dice my father had specially made for him in Vegas in the 1960s. He's no longer with us, but his legend lives on.

Right neck Danny Kelly l **Left and right biceps, left forearm, chest, stomach, upper and lower back, right calf** Nikole Lowe

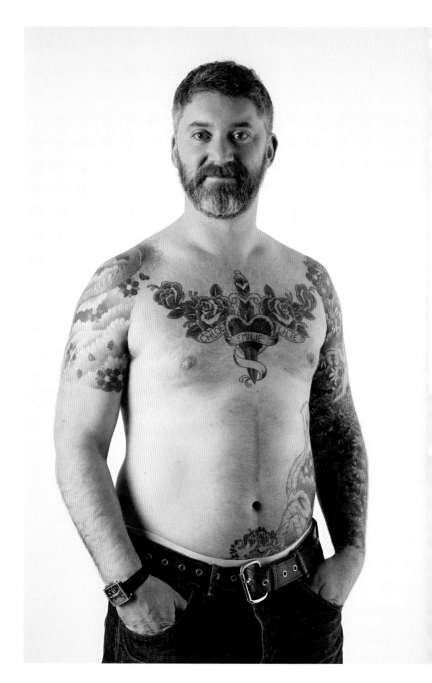

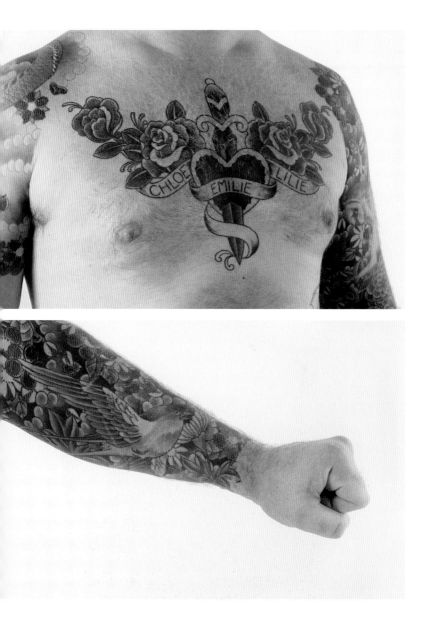

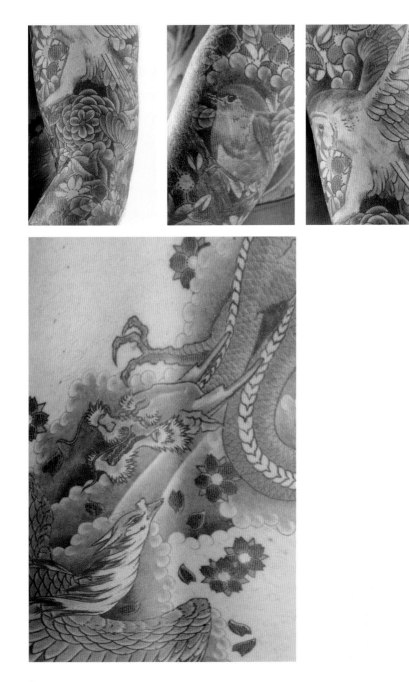

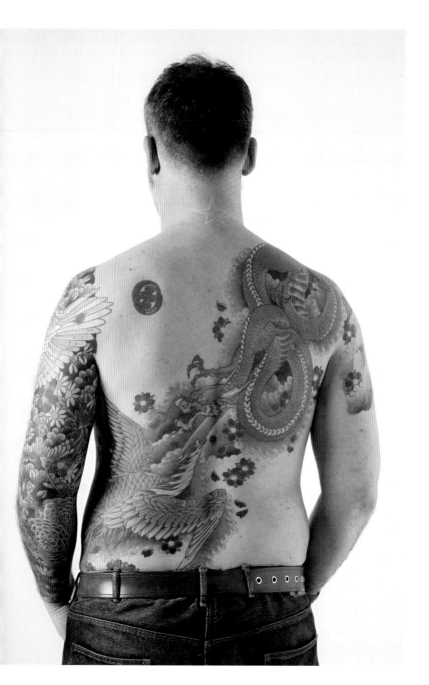

Bee Nguyen

Age: 27

I've always wanted a tattoo that was unique and that had some personal meaning or message to myself. I've spent the past four or so years living in London and travelling the world. I wanted a tattoo to remind me of this amazing experience and also how happy and lucky I am to have seen and done all the things I have. Incorporated into my design are some of my favourite cities and sights from around the world: mountains from Japan, the Empire State Building, Eiffel Tower, Big Ben in London — my home away from home — and then finally it ends with Sydney Harbour Bridge, the place that will always be home to me.

Right ribcage Noon

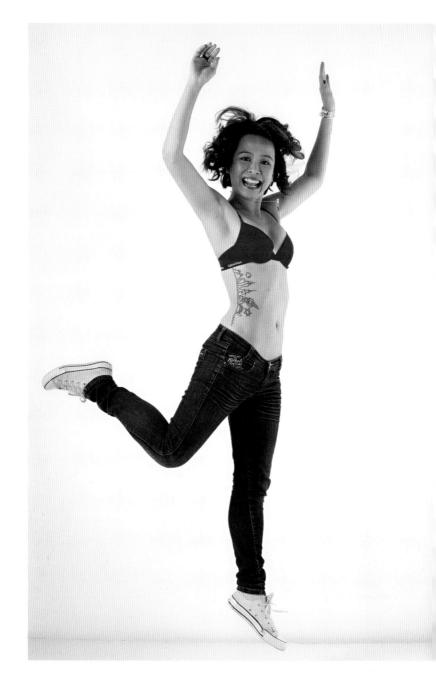

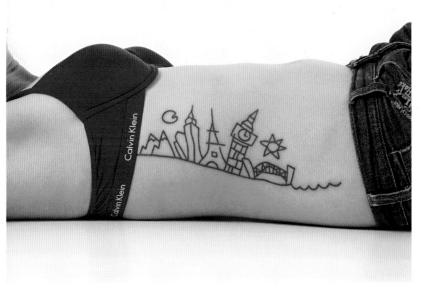

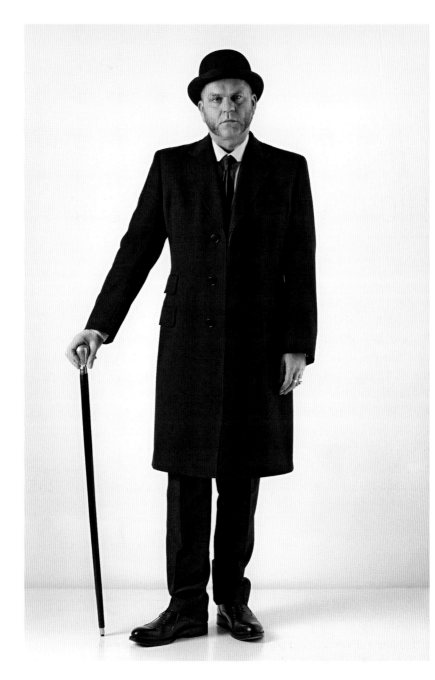

Professor
Richard Sawdon Smith

Age: 47

I'm head of the Arts and Media Department at London South Bank University.
My tattoo is a very personal project made public. It speaks of living with a long-
term incurable illness that requires regular blood tests on a tri-monthly cycle for
the last 16 years, making visible the internal and highlighting this regular routine.
They were done in 2009. The tattooing (a process that draws blood) of medical
illustrations depicting veins and arteries coming from and feeding into the heart
is in response to the nurse seeking to draw blood from the veins to check for signs
of (ill) health. I will be extending this tattoo, with veins and arteries down the torso
and onto the legs, with images of the lungs and kidneys. In addition I intend to
have autopsy scars tattooed down my back, as if I had once been opened up and
stitched back together again.

Left and right biceps, left and right forearms, chest Piotrek | **Stomach above
groin, lower back on bum** Mr Sebastian

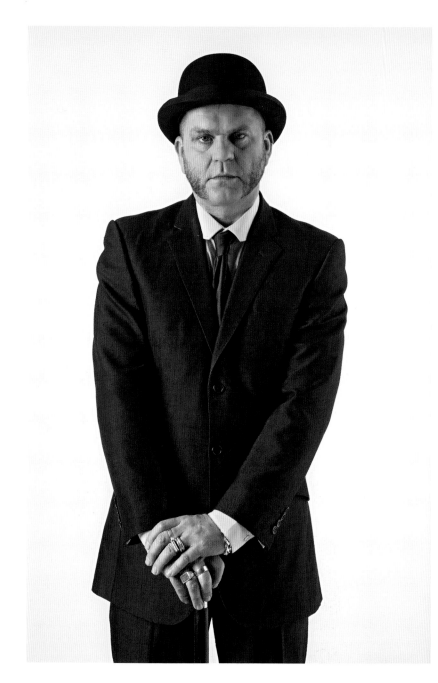

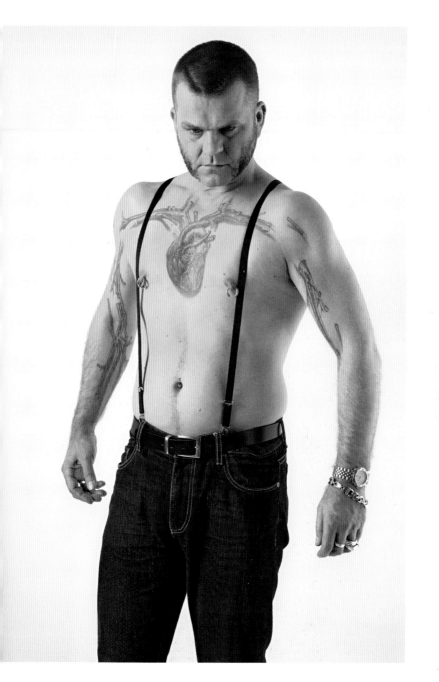

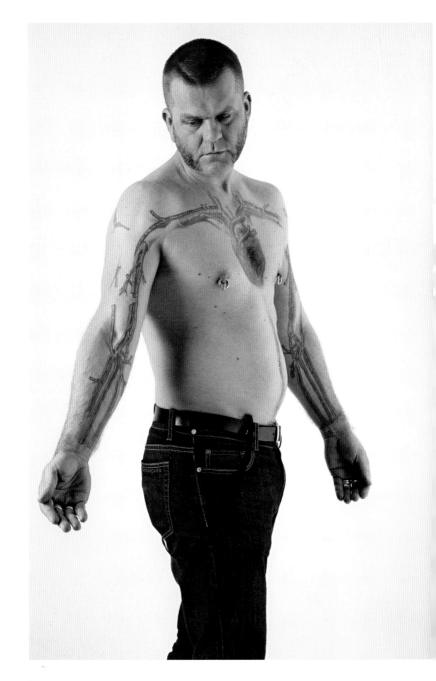

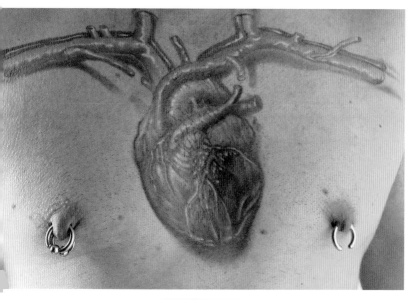

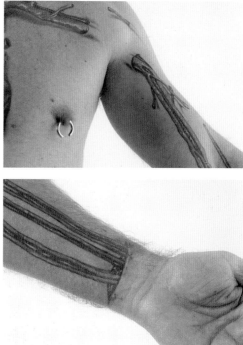

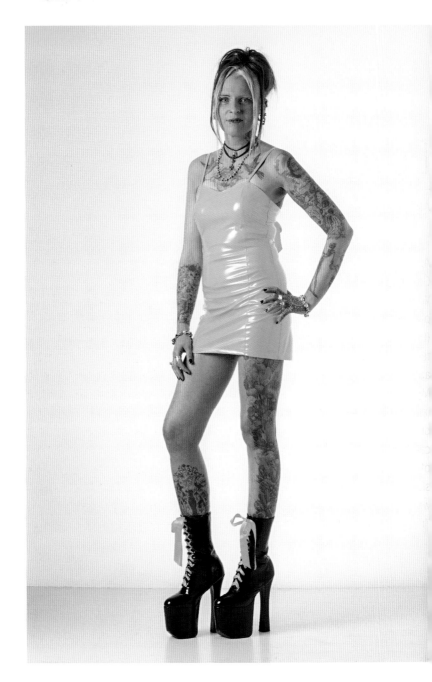

Edyta

Age: 40

All my tattoos represent things I love deeply: horn of fruit is because I'm vegetarian. Gramophone: I'm in love with their shape, sound, and of course with music. With my husband I collect 78rpm shellac records and play them on our wind-up phonograph. Dalí: he is my favourite artist. But this tattoo is also for art I adore there are so many artists I like that I'll have to have a very big body to show just few of their paintings or sculptures). We started work on my jungle tattoo so long ago, and up until now only the tiger and the hummingbirds inhabit my private forest. My hand tattoos are a tribute to the traditional tattooing art from which new ways of tattooing evolve. I'm planning to continue the same style on my feet and on my face, but my husband is not very happy about my plans for tā moko [traditional Maori skin carving]. The rest of the body will be covered in coloured ink. I have plans for all of my body (all connected by earthly things I like), but the tattoo work is going very slowly. This is because the 'main' artist is my husband, so I'm getting tattoos only when a customer cancels. But now we even have a queue for cancellations so I'm getting tattooed not more than once a year. I can't say that I'm happy about this.

Head Mirek Vel Stotker at Stotker Tattoo I **Left hand** Chime

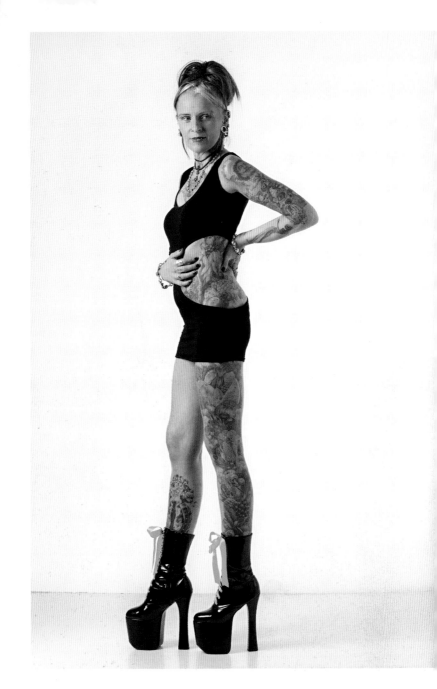

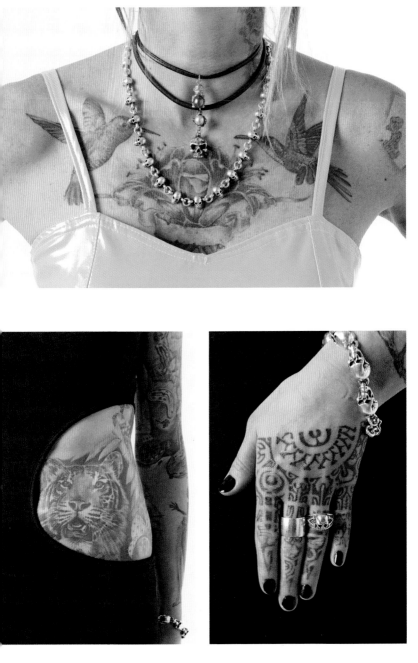

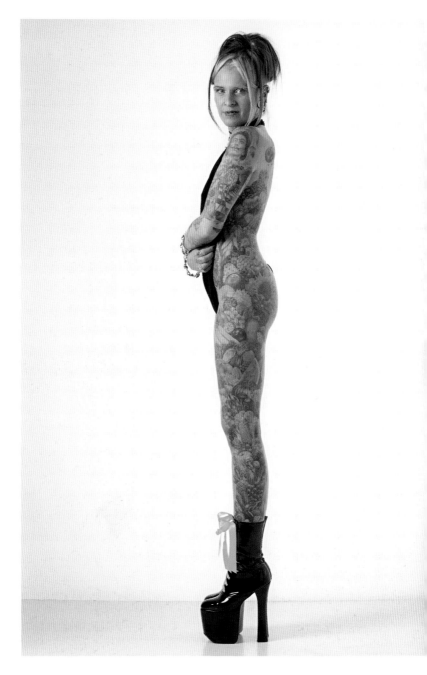

like to eat fruit and veg, but I also love how they look, their shapes, colours and their diversity. I'm treating them like part of my diet and home decoration.

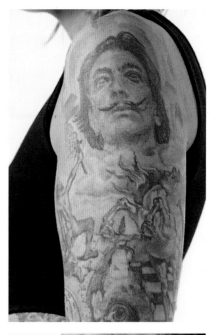

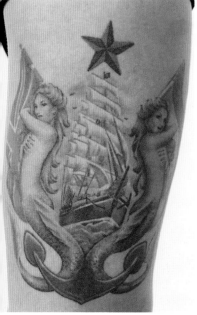

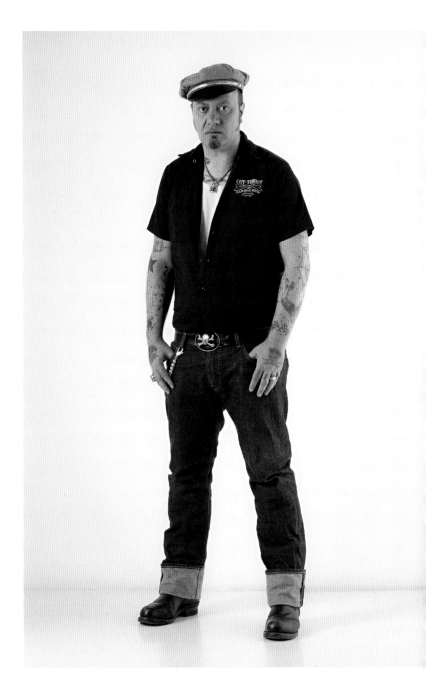

Mr Ducktail,
Rock 'n' Roll MotherKutter

Age: 44

There's no real meaning with my tattoos. When I was younger, it was just, part of being a rocker. Lots of bands and artists I was a fan of had tattoos, especially my favourite one, Brian Setzer from the Stray Cats. I took the decision to have tattoos because of this band and my first one was the Stray Cats' logo. My next tattoo will be two pin-ups taken, once again, from one of Vince Ray's designs.

Left and right neck, left and right hand Jammy Tattoo, France | **Left bicep** Tin Tin, France. Fantasia, France | **Right bicep** Tin Tin, France. Fantasia, France. Jammy Tattoo, France | **Left forearm** Werewolf, France. Jammy Tattoo, France | **Right forearm** Mr Greazz, France. Jammy Tattoo, France. Phil Kyle | **Chest** Jammy Tattoo, France. Fantasia, France | **Upper back** Mr Greazz, France. Sunny Buick

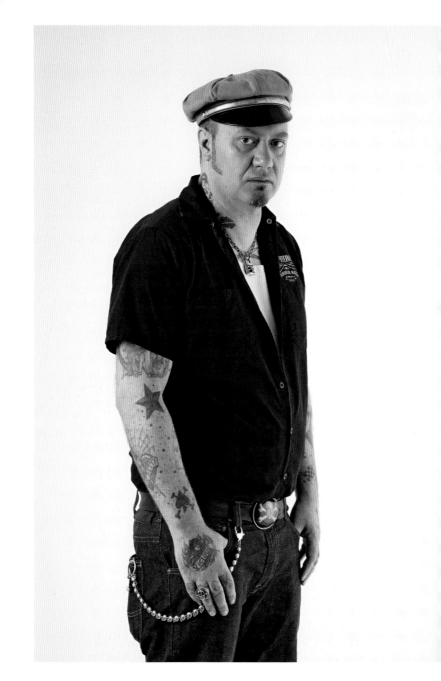

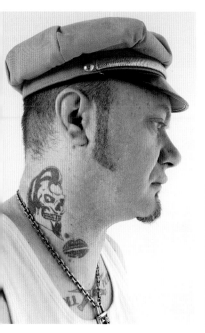

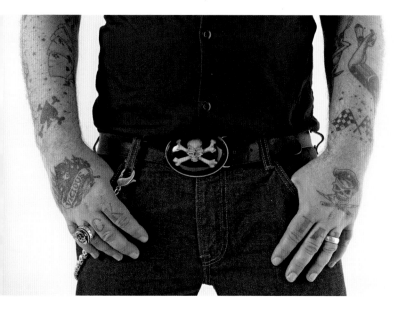

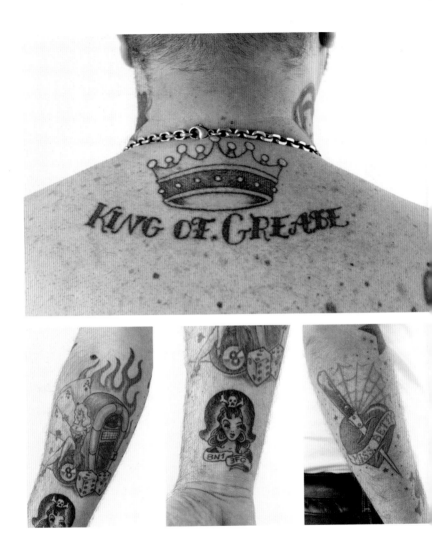

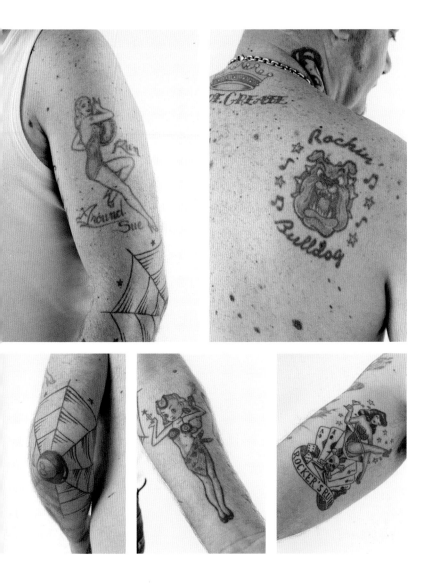

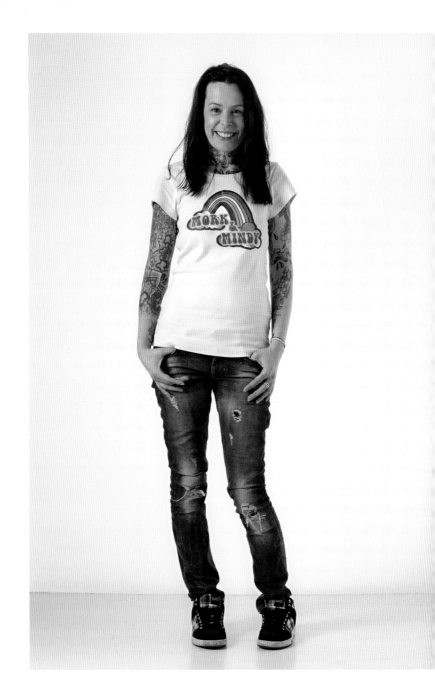

Ness

Age: 35

My tattoos are a snapshot in time as well as a loose representation of people I love. I'm a little bit odd, a little quirky, but I embrace that and my good friends love that about me. My highwayman tattoo (unfinished) is a nod to Adam and the Ants: I dressed as a highwayman for years when a small kid because of the song 'Stand & Deliver', complete with plaited hair and a white stripe across my nose. My chest piece, an anatomical heart with Latin, is my own reference to religion. It represents a Sacred Heart but says 'Nothing is Sacred', as I don't feel that anything is sacred in the eyes of the church. Bas Bleu is on my arm as respect for 'bluestockings', educated and intelligent women, much like myself, as I get the feeling people don't understand that although I am heavily tattooed I am also well educated and intelligent. My zombie bite is a nod to films of old and being 'made' to watch them by my brother when the parents went out for the evening. I have a memorial tattoo for 9/11 as well. It represents events on that fateful day, but also includes a cupcake so that I can feel like I can celebrate my birthday, which is also 11 September. I checked with a lot of US friends before dedicating this one to flesh, as I didn't want to cause any offence.

Left and right neck, left and right bicep, right forearm, right thigh Neil Bass I **Left forearm** Chris Higgins (cupcake 9/11). Neil Bass (Bas Bleu) I **Left hand** Adam Sage I **Chest** Chris Higgins I **Stomach** Khan (praying dog) and Jed at Inktruzion (ragfish) I **Upper and lower back** Lee at Inktruzion I **Left calf** Dan Gold I **Right calf** myself

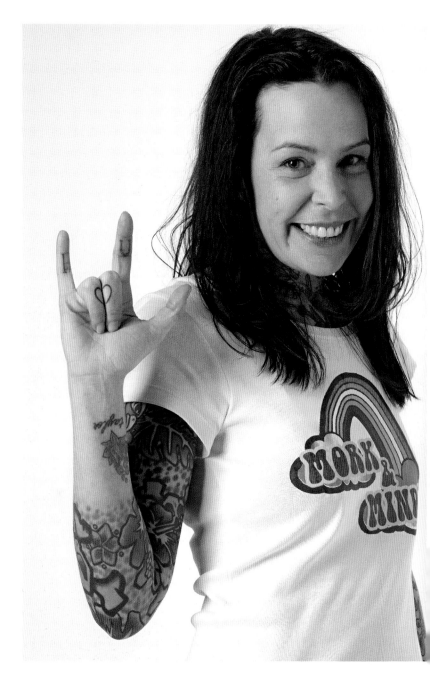

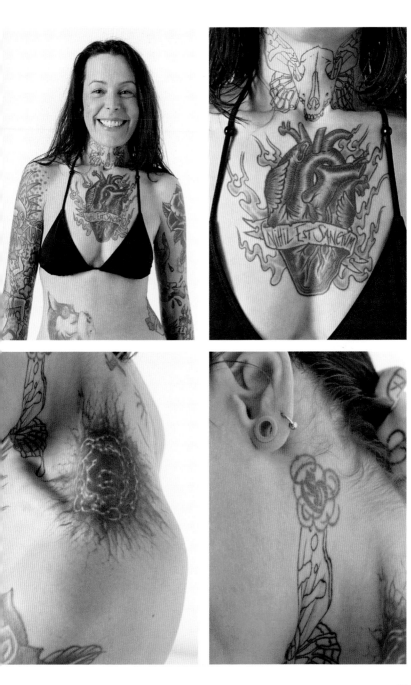

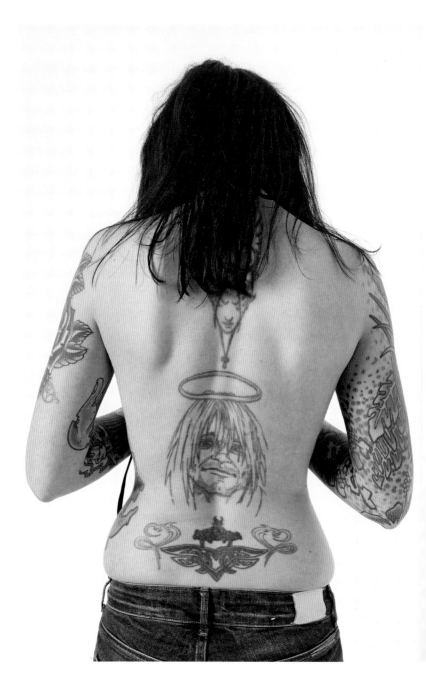

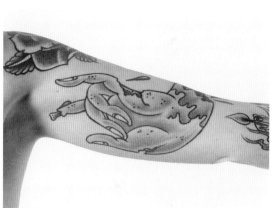

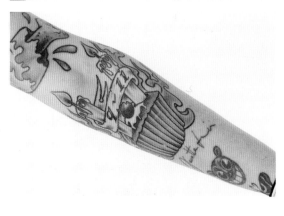

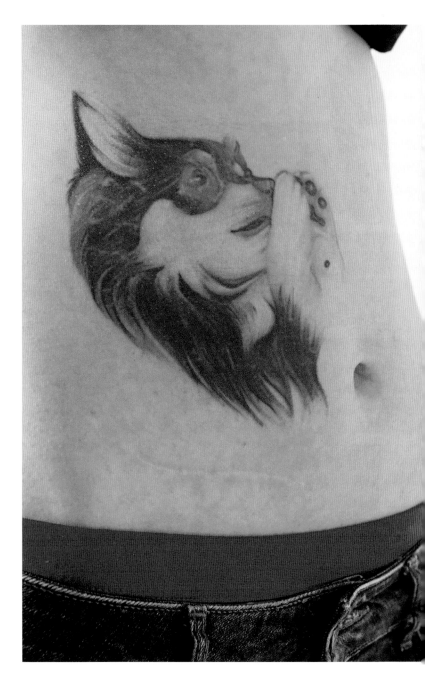

The praying dog is a real dog from Japan,
Shuri Kannondo Temple in Okinawa islands and
owned by priest Joei Yoshikuni. I like the idea
that a dog has learnt this behaviour, and although
he isn't praying in the traditional sense,
they believe he is giving thanks for walks and treats.

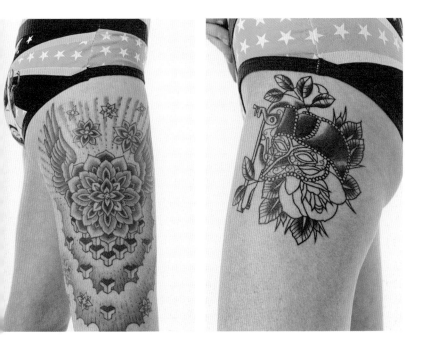

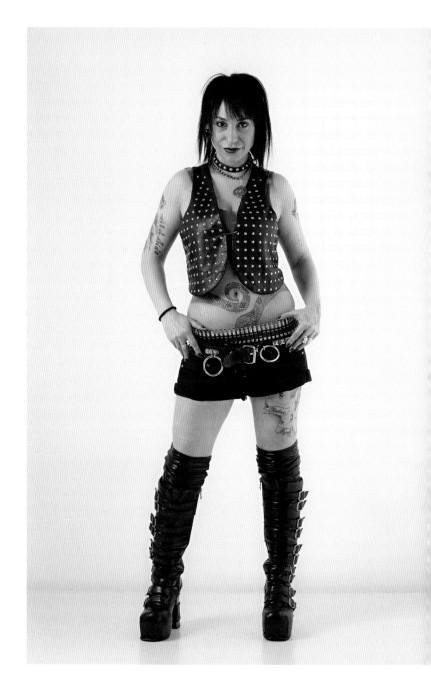

Snake Girl

ge: 29

or me tattoos are a way of expressing who you are, with your fears and pride.
did my first tattoo when I was 18 years old: it is a daisy with a symbol of peace
 the middle. The second is a little Egyptian-style cross, located on the left side of
y navel. I have my left hand tattooed with a thin branch with leaves, representing
rth and growth inside. Another tattoo is similar to that which I have on my right
g, tattooed by my good friend Desi, a tattoo artist from Valencia. My first tattoo
 London is on my left arm and is a very playful Bettie Page, with a devil's tail.
his is my naughty side. The tattoo many people recognize me for is a snake
ound my waist. The reason for this tattoo is very simple: I believe that all women
e like snakes, hunters, seductive, intriguing. On my left arm I tattooed my wild
de: it's a tear in the skin so it appears as if my skin was true leopard. Behind my
eck is Foxy, a little tribute to my boss where I work at The Intrepid Fox. My last
ttoo, which I am very proud of, is a memorandum for my lost family members.
hey are always in my heart and soul so I wanted to create a paradise for them:
 my left leg are four flowers, each representing one of my family with their initials
 the middle of the flower and what each means to me, with the heat of the light
 hope lit from the sky.

ft forearm Loren I **Right forearm and neck** Mauro at True Love I **Left hand**
ist from Spain I **Left leg** Alexandre Mansuy I **Right leg, right buttock** Desi,
lencia I **Waist** Designed by Bergamind Claudio, tattooed by Loren

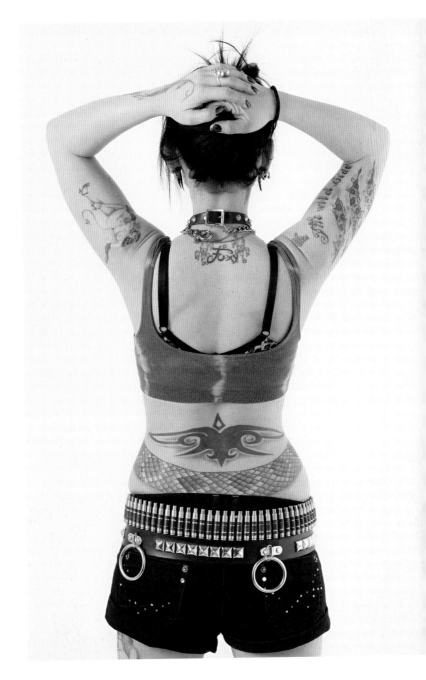

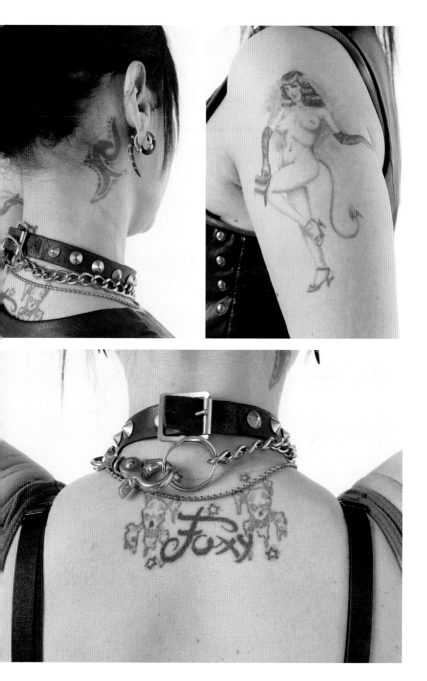

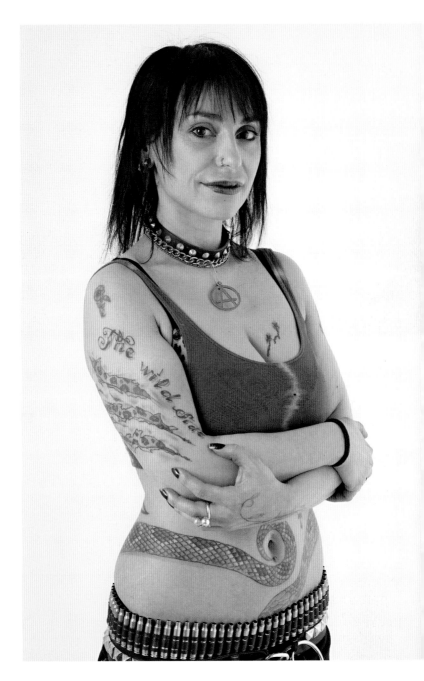

have a vampire bite on
my breast — love means
you can remove blood
from the heart!

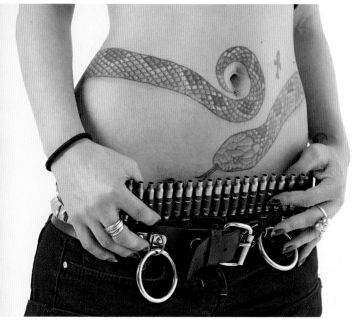

Simon Henry
aka Mr Tarquim

Age: 34

The 'Innersense' graffiti came from old school rave from the early 1990s and my love of tagging anything that moved. My tattoos reflect my love for dance music and deejaying and large parties all over the world. These things changed my life and have given me some amazing memories and I wanted to express them in the loudest way, and with the help of my tattooist I think we achieved that quite well. My next tattoo will be a celebration of my new baby daughter, a deejaying baby sitting on the side of the road.

Head, upper and lower back Dan Gold

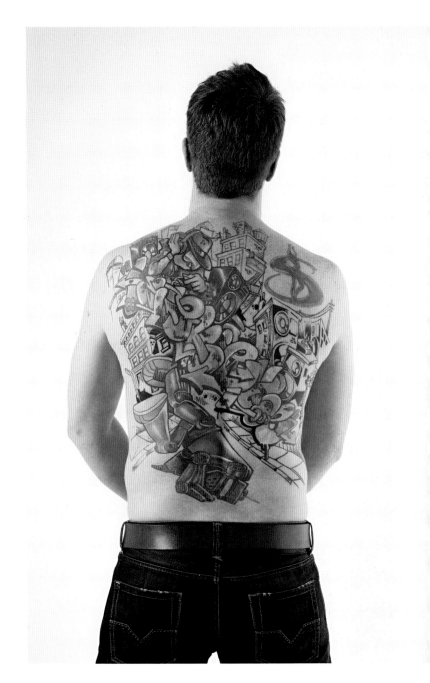

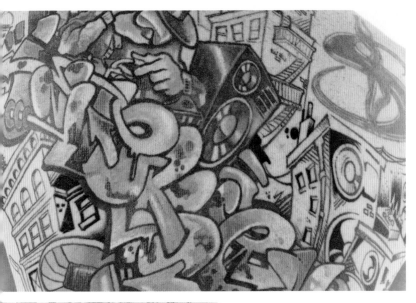

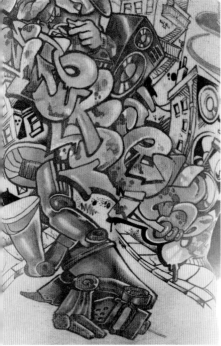

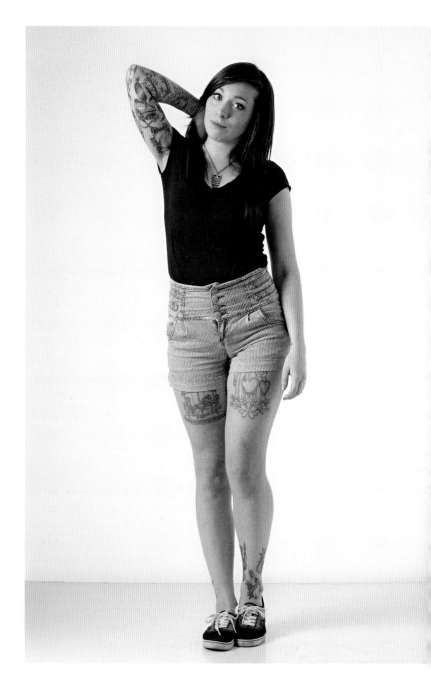

Liberty Smith

Age: 23

The majority of my tattoos don't have any meaning: they're just pieces I feel are beautiful or fun. My first tattoo was the lyrics on my wrist from the song 'In This Diary' by The Ataris: 'The only thing that matters is just following your heart, and eventually you'll finally get it right'. Although they're cheesy I still find them to hold truth. I have a few matching tattoos with the people closest to me. The locket on my ankle is a matching piece with my ex — he has a skull locket with a heart key. I have a small pair of spoons on my other ankle which myself and my best friend both have because we like to spoon. And I have a small bottle on my leg with a banner and the letters TTFU, an in-joke from my favourite summer spent with another of my best friends. I'm getting my thighs finished later this year and maybe added to or altered slightly. I'm really looking forward to it and I've found an artist who I know will finish them beautifully. The next big piece I want is Laputa, the castle in the sky. The idea was originally taken from 'Gulliver's Travels' and made into a film by Hayao Miyazaki. The castle itself is huge and with a great amount of detail, so it would properly take up the entire right side of my torso. But I want to find an artist with an understanding of Laputa to tattoo it, so I'll keep researching.

Right bicep, right forearm, lower back, left and right thigh Albert Thomas |
Left calf Jethro Wood | **Ribs** Elisabetta Manzolini

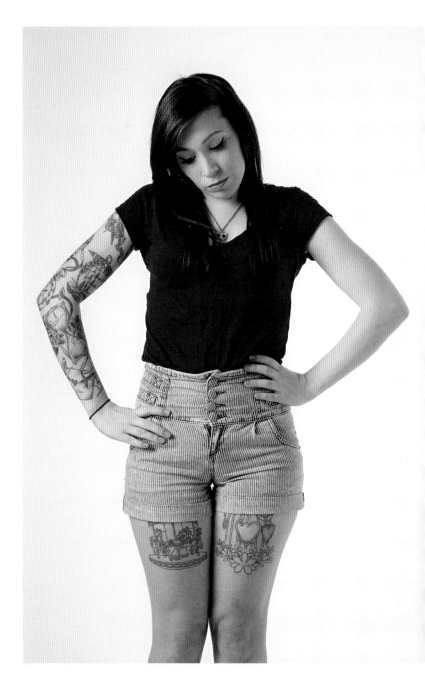

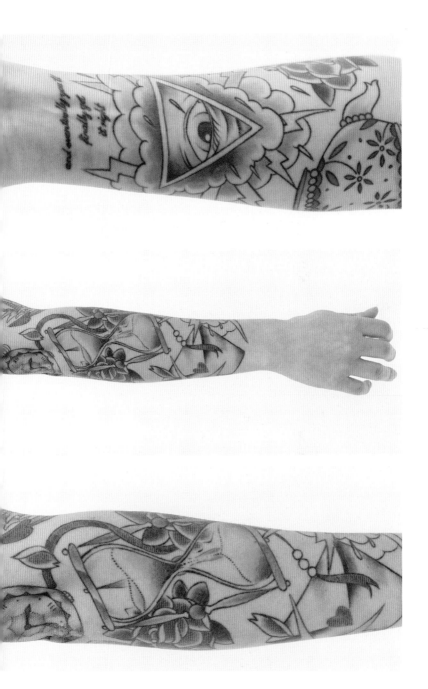

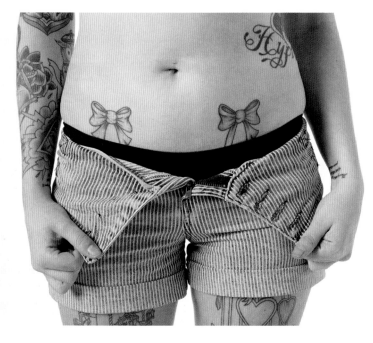

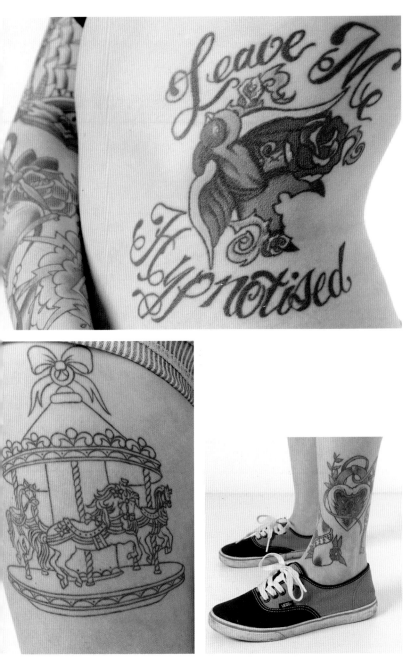

Ashley Jagdeo

Age: 28

...own Pure Ink Tattoo Studio in Soho. I am not an artist, and I don't plan on being
one. I have worked in public relations for the last ten years and have now quit
my job to work at the studio full time, taking care of our clients and running the
day-to-day business. I kind of look at it as retiring into something that I adore.
I have been collecting tattoos for well over a decade now. Some I have booked
in with other studios and been a client, others I have got from the friends I have
acquired since working in the industry for the last few years. They are indelible
marks that represent times in my life that will be with me forever, constant
reminders of the good and the bad, that are very special to me. The same as
a lot of people who want at least 70 per cent coverage, I have quite a few pieces
that I need to get finished: that is my main priority at the moment. However, by
the end of 2011 I am planning on having a black and grey version of the Salvador
Dalí 'women skull' photograph as my back piece.

...eft neck, right calf Bruno Jardim | **Left bicep and forearm, left calf** Marcio
Bornholdt | **Left and right hands** Iris Lys | **Chest and left thigh** Gary Donnelly |
stomach Bruno Jardim. Marcio Bornholdt

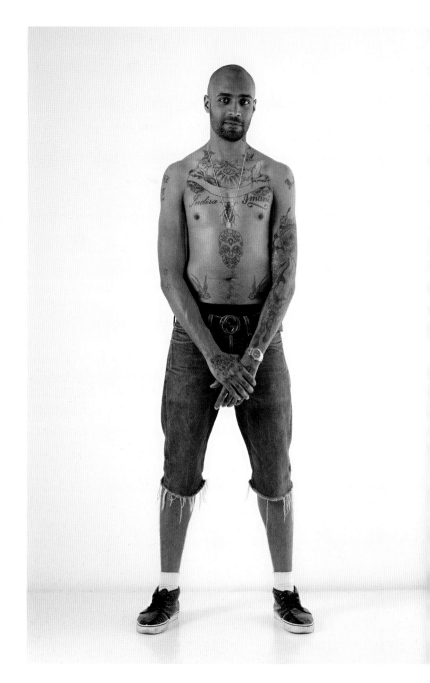

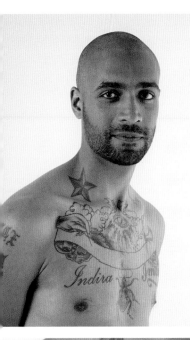
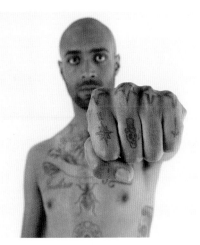
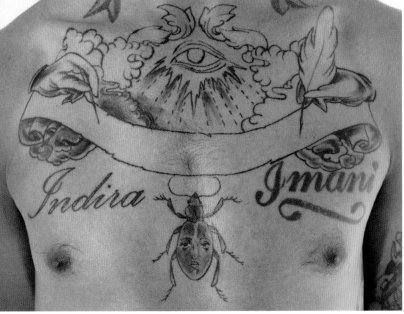

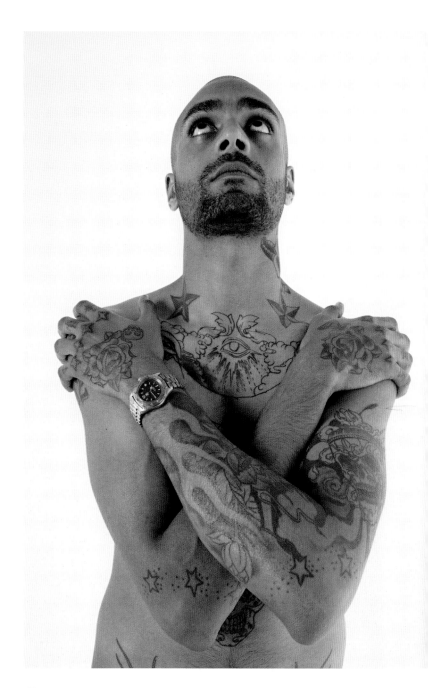

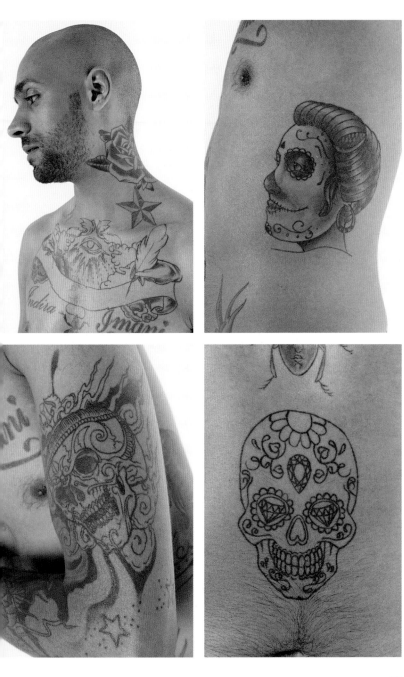

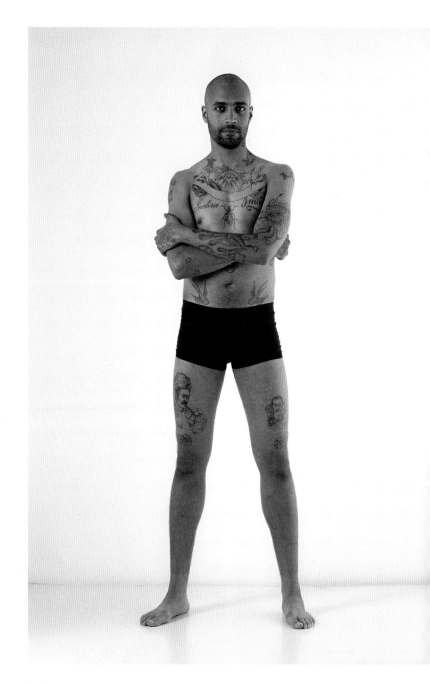

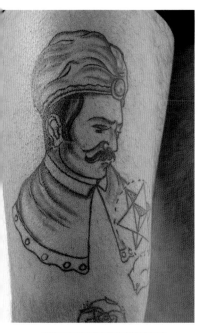

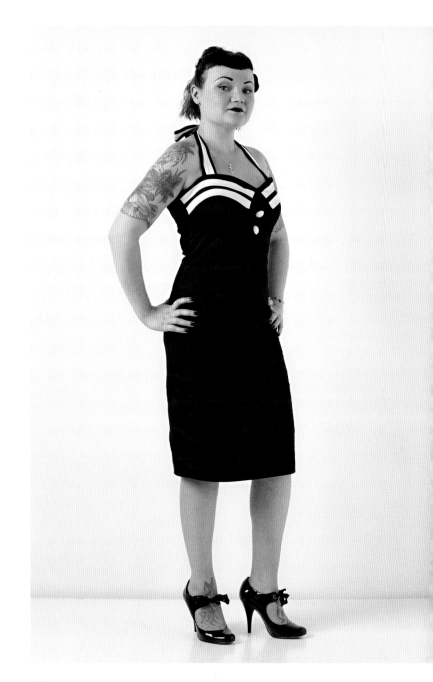

Emma Gates

Age: 27

My tattoos are such an integral part of who I am. I am proud to make my skin a living canvas. I have been fascinated with tattoos since spotting a group of heavily tattooed punks one holiday at the age of eight or nine. Even at that young age I fell for the beauty and self-expression of decorating your skin. For me it's not about turning heads or standing out from the crowd. My love of traditional Japanese art and culture made my predominant tattoo choice obvious. I guess I wear them almost as talismans, having carefully selected images that represent good fortune, strength, wisdom and healing, fertility and prosperity and the transience of life. The Geisha is a nod to the arts and entertainment industry I work in, and also what I consider to be the ultimate symbol of femininity, while the tattoos on my wrist are a small homage to the 1950s and the Rockabilly look that I adore. It is very important for me to find an artist to work with who has the same passion for Japanese-style tattoos as me, and I love to give them ideas sourced from original woodblock prints and watch it grow into a unique design. I am going to get a couple of Hokusai-inspired rabbits and cherry blossoms on the backs of my legs, and a phoenix in blues, yellows and gold on the opposite side to my snake. Then I will concentrate on tying all my tattoos together, finishing off my upper legs and the rest of my back.

Left bicep, upper back, left thigh, left foot Aaron Hewitt | **Right bicep, left forearm** Hayley Hayes | **Right forearm** Adam Sage | **Lower back** Unknown | **Left thigh** Aaron Hewitt | **Right thigh** Hayley Hayes. Unknown | **Right foot** Unknown

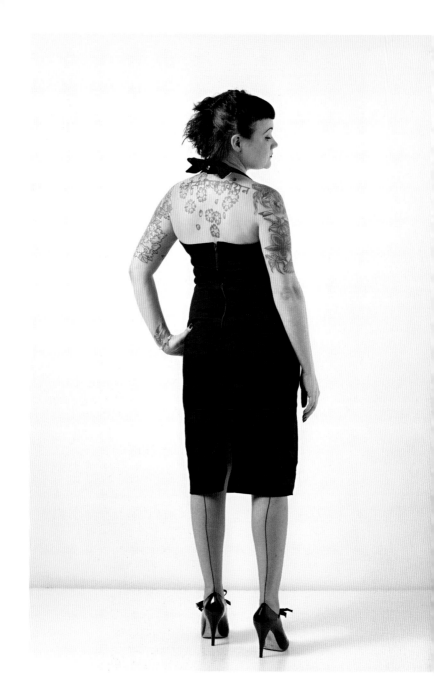

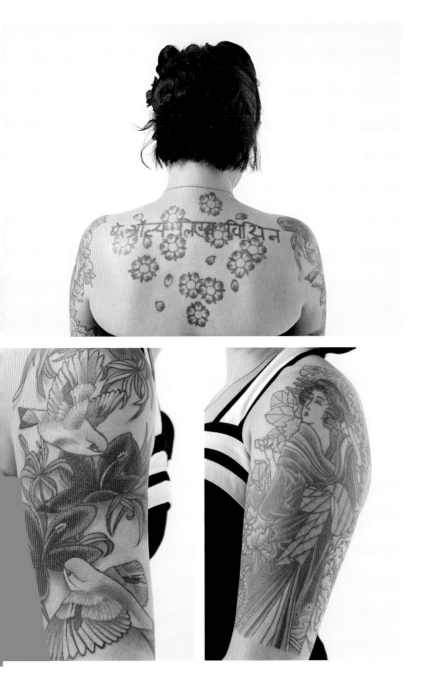

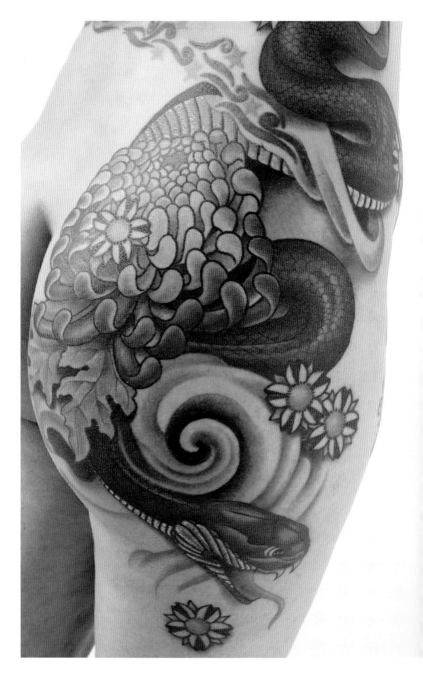

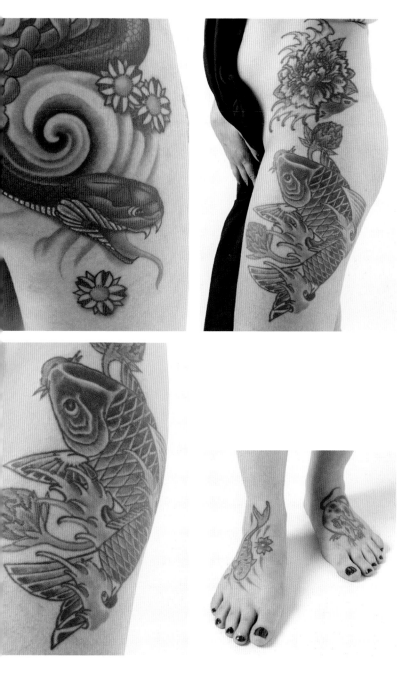

Thomas

ge: 29

always liked Japanese art and the stories behind it, that is
hy I chose the two Koi going upstream. Next I am getting a lotus
nd waves on my calf.

per back Kanae n

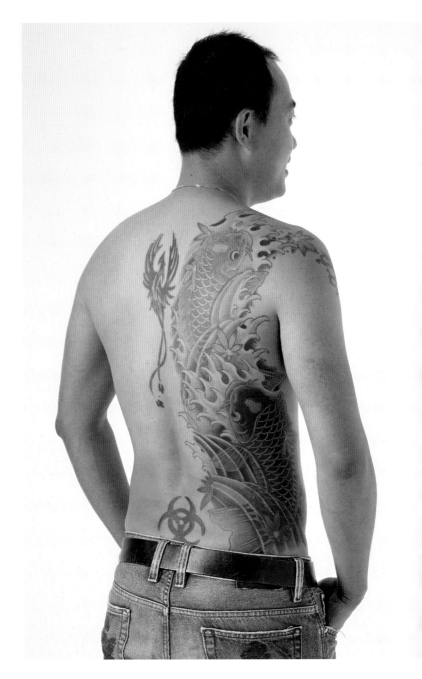

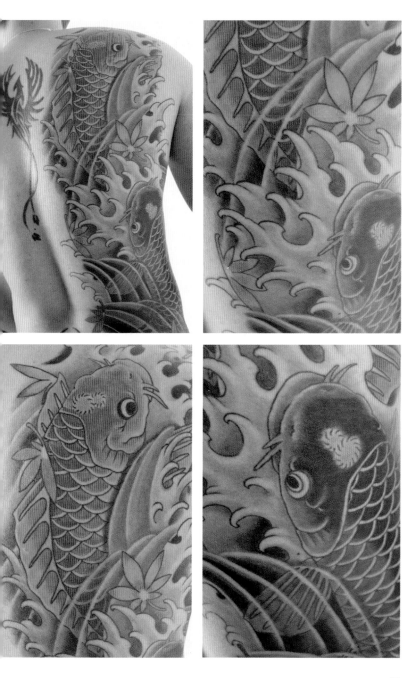

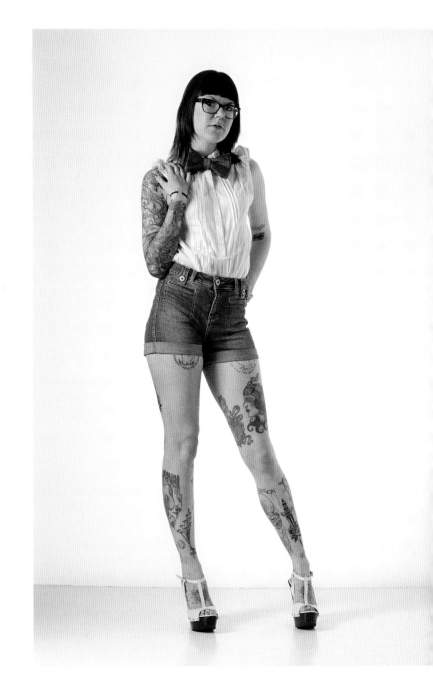

Joanne Danielle Squires

Age: 25

I got into tattoos through the music scene, and from seeing tattooed musicians, as I'm sure is the case for a lot of other people. It is very indicative of my character that I knew from an early age, maybe 14 or 15, that I would end up being heavily covered — I tend to be very enthusiastic about my 'hobbies'! After getting my first few from street shops of questionable repute (the only places that would tattoo me at that age), I soon sought out the better artists and studios, often travelling to London. Some of my tattoos mean a lot. However, a lot of my tattoos are purely aesthetic. I know this is a controversial concept for some people to understand, especially now as we are bombarded with TV programmes preaching to us that tattoos MUST tell a personal tale of love, loss or triumph over adversity. Some may argue that, as fashions and trends change, what is aesthetically pleasing now may seem dated or even vulgar in the future with no 'story' to anchor it to. But I have chosen to use my body as a canvas to display my collection. My next tattoo will be a portrait of my grandparents on their wedding day, on my right thigh — a rare example of a meaningful tattoo for me. My grandparents were heavily involved in bringing me and my sister up.

Left neck James Hate I **Right bicep and forearm, upper and lower back, right calf, fingers** Steve Vinal I **Left thigh** Drew Horner. Iain Roberts. Muckster I **Left calf** Hannah Aitchson. Kamil I **Right calf** Steve Vinal. Hannah Aitchson. Xty Skinscribe. Toby Caldicott. Rose Whittaker I **Left wrist** Jo Harrison

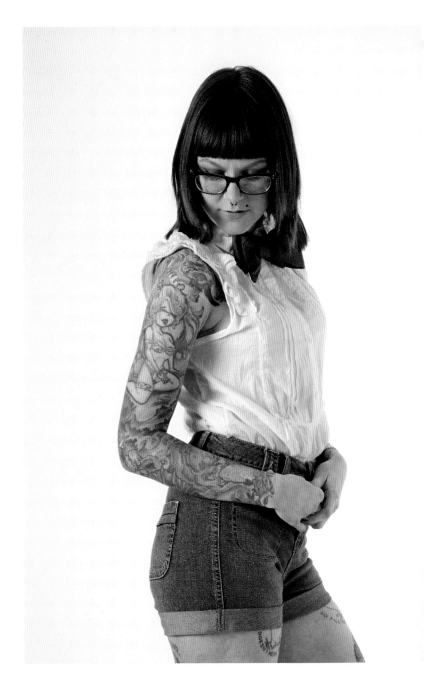

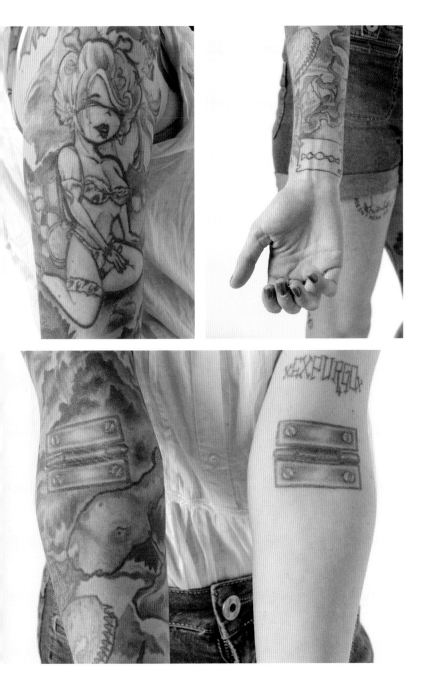

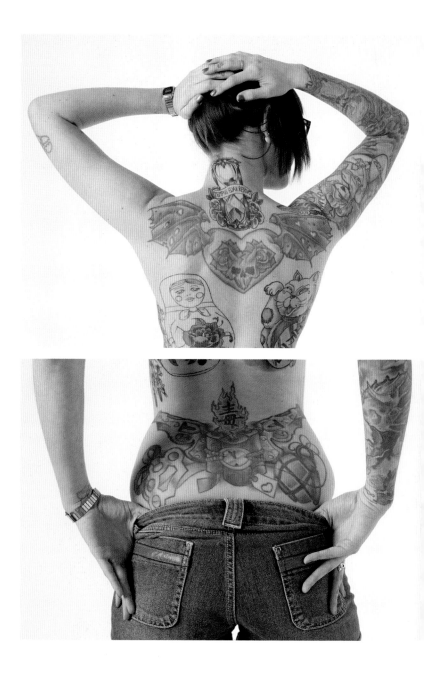

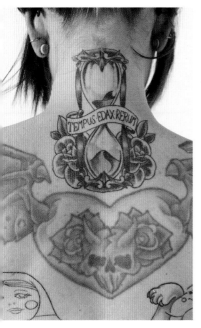

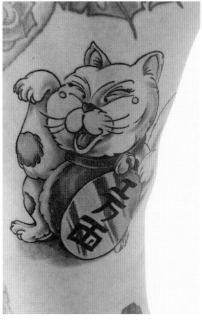

have matching tattoos with my husband and my sister, and others to remind me of specific significant events in my life, both good and bad.

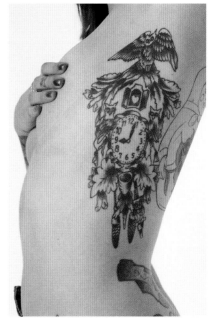

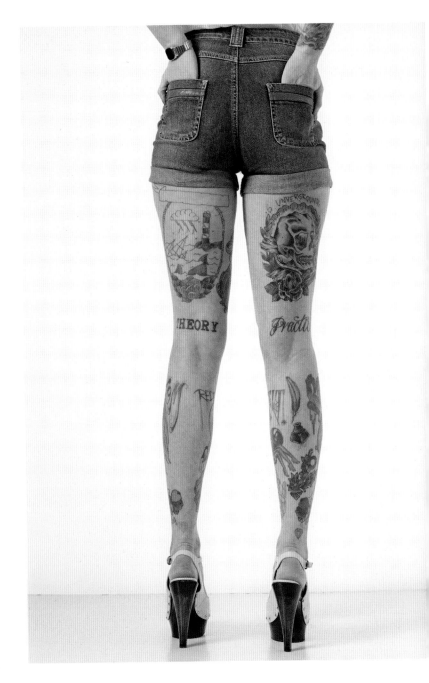

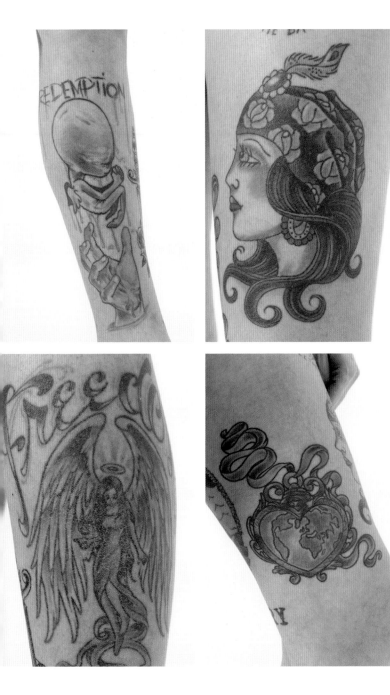

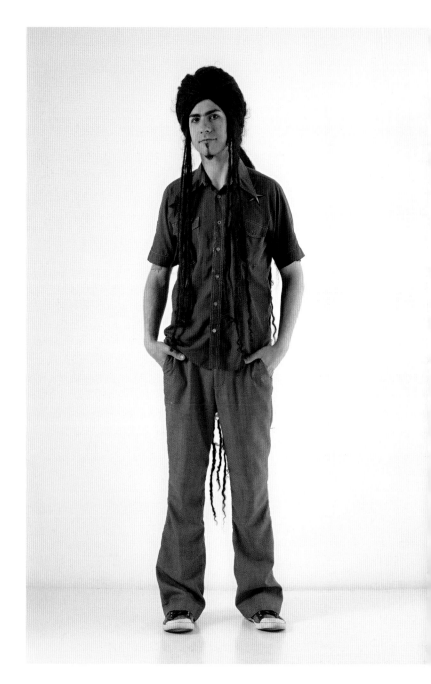

Pinnetto from Elephant 12

ge: 34

eing an artist I compare my body to a canvas. Tattoos are to me a pure form of
ecoration and artistic expression. That's why I choose the artist very carefully
efore booking a session. I don't really believe in those fashion victims who get
ttoos because it's trendy. I've seen some people walking into a studio without
clue of what they want or not checking out at all the standard of the artist's work,
omplaining about the pain after five minutes and walking out with some bad job
 some tacky character/subject/statement on their body that is going to be there
rever. It's so true that tattoos, just like music and food, say a lot about a person.
y next tattoo is probably going to be a number 11 on my wrist because I was
orn in November and because it's a master number in numerology. During this
ear this number will be repeated quite a lot, that's why it's going to be a very
owerful one.

ft bicep Tomas at Into You. Matt Difa at Jolie Rouge I **Right bicep** Artist at Sacred
t. Artist at Bugs I **Chest and stomach** Andro Casalegno

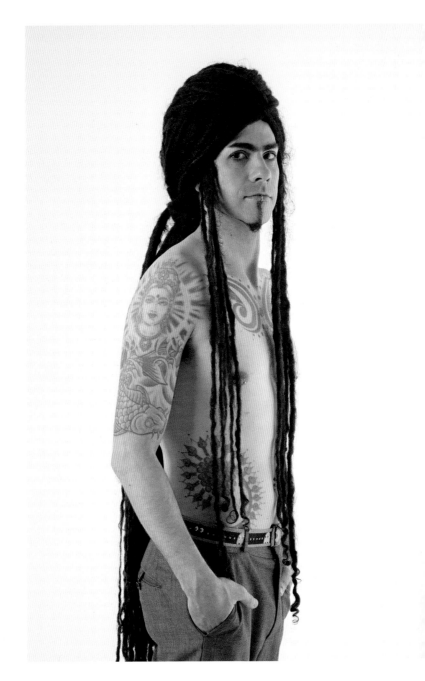

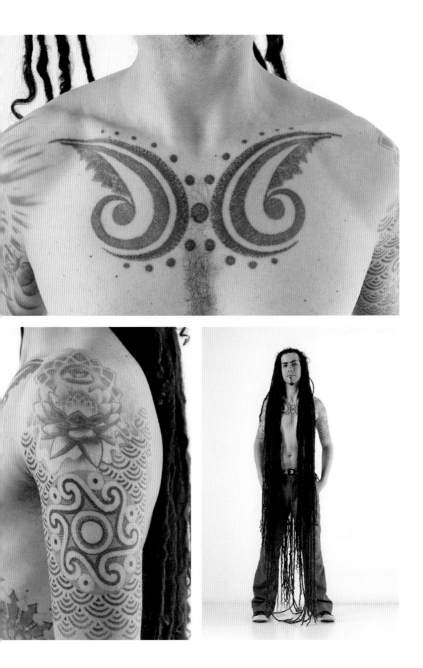

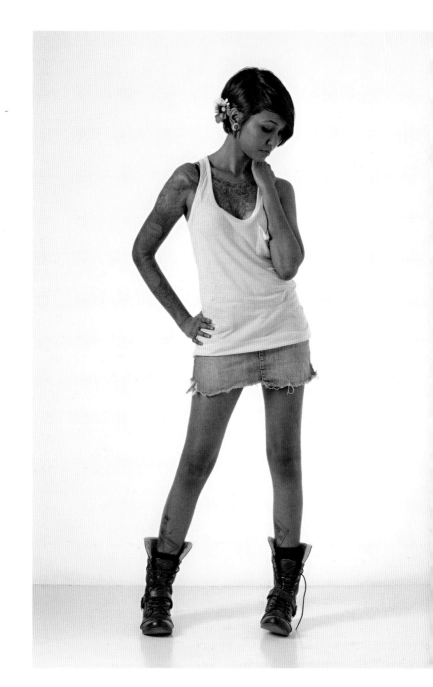

Koshil

ge: 25

or me, my tattoos are a means of expression. A way to put my inside thoughts
n the outside. Also they are a way of marking an end of a chapter in my life.
ll of my tattoos have a meaning which is personal to me. I've never been one to
et a tattoo on a whim: for me these are permanent reminders of what I have been
rough and of things I have accomplished. For example, my chest piece is deeply
ymbolic to me. It is an armoured, covered heart with a piece missing that reveals
real heart inside. This is about a part of me that I never knew existed being
wakened. My sleeve is based on my love of the creative and magical world of
ime. We started the sleeve in 2009, and after putting in all my favourite characters
ere was still a big gap to be filled. I wanted to wait until I found the perfect image
really bring the sleeve together. I wanted it to almost be like a Japanese 'Alice
Wonderland'-type scene but needed the perfect image of a girl. It was only recently
at I came across the artist Audrey Kawasaki and saw the picture and knew
stantly that was the image that would bring my sleeve to life. My next tattoo will
e the start of my 'Romeo and Juliet'-themed sleeve. I'd like to start it in a few
ears, and I think when I meet the right artist I will know and it will be easy to come
o with the perfect design.

ght bicep and forearm, chest, upper and lower back, left thigh Dan Chase at
tual Art Studio, Rainham, Kent | **Stomach** Anu

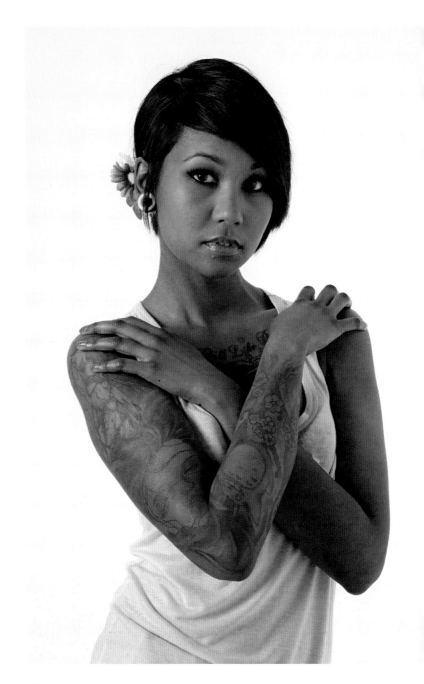

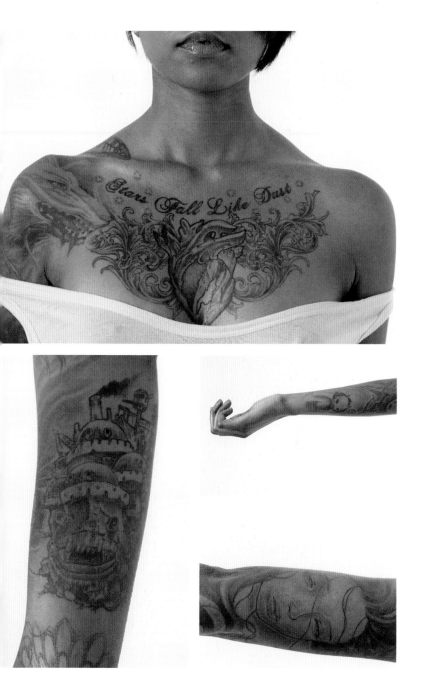

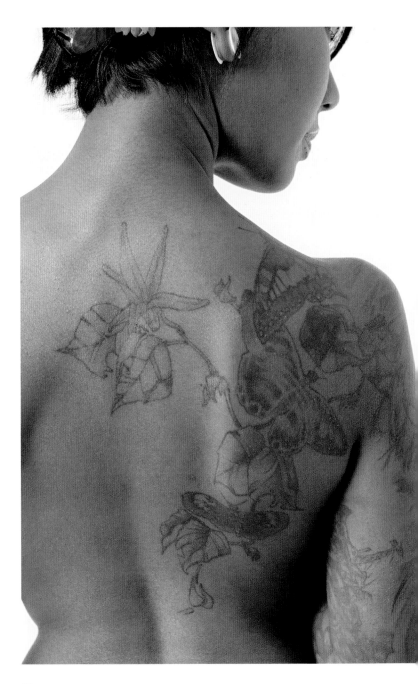

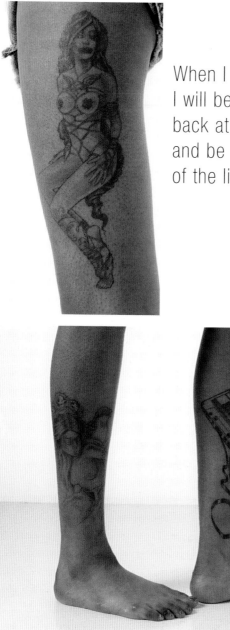

When I get old
I will be able to look
back at all of my tattoos
and be reminded
of the life I once had.

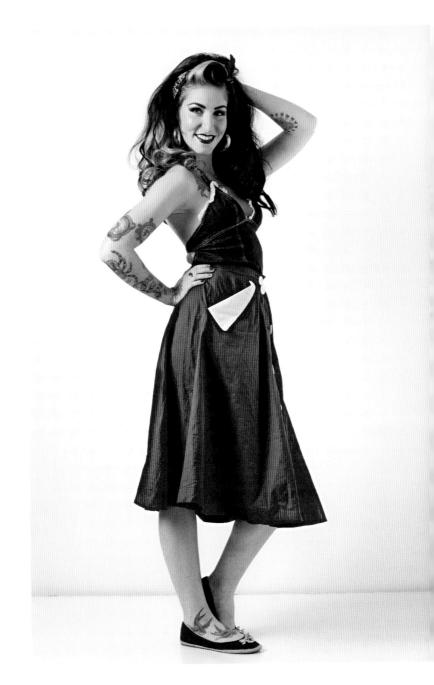

_uki Goddi

Age: 27

one of my tattoos 'mean anything' in the sense that they are not marking stages in my life, or commemorating anyone. I feel like they re all my children, I love them all equally! My next tattoo is going ɔ be a circus zebra rearing up, on my left leg.

ll by Jeff Ortega at Evil from the Needle, Camden…apart from about three that can't quite remember at the moment…

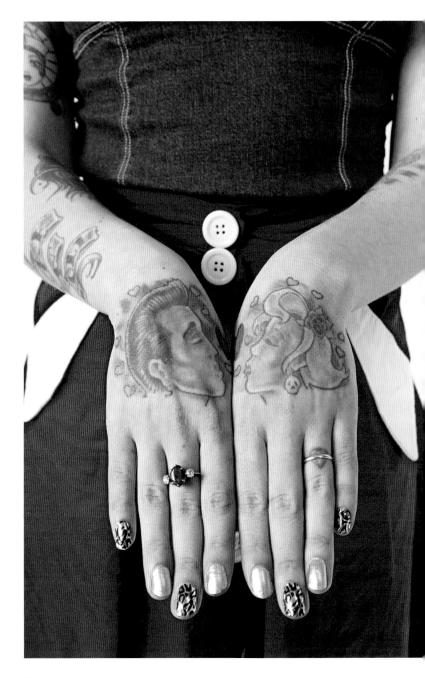

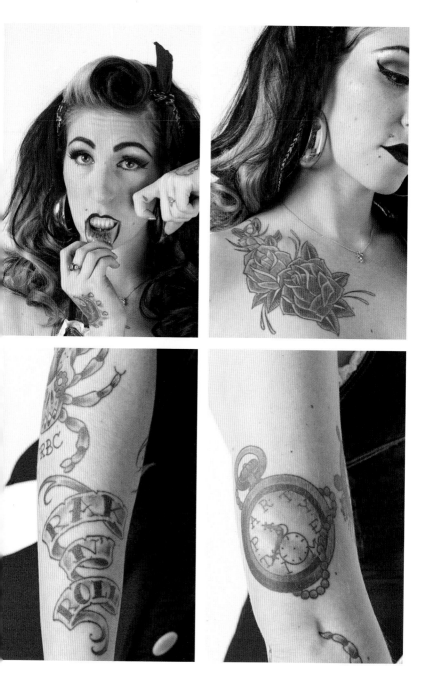

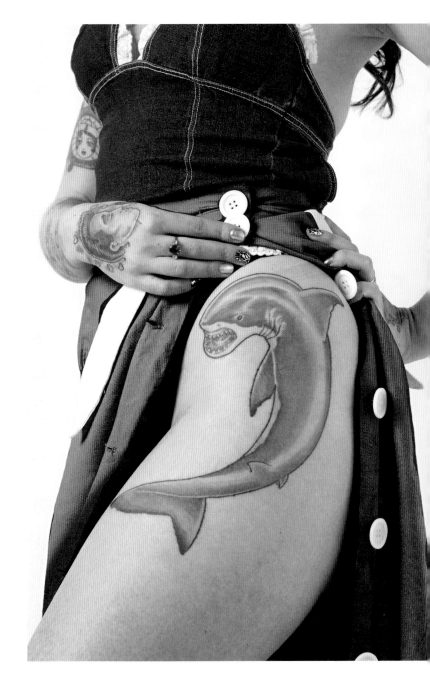

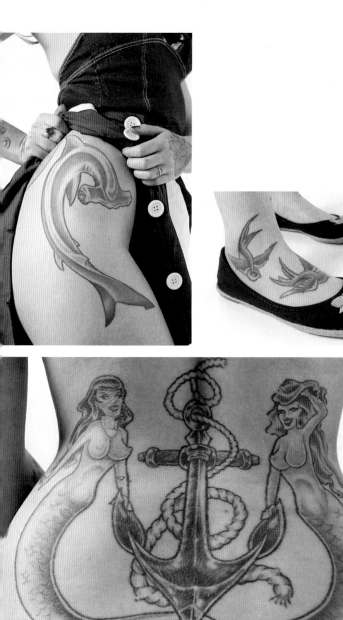

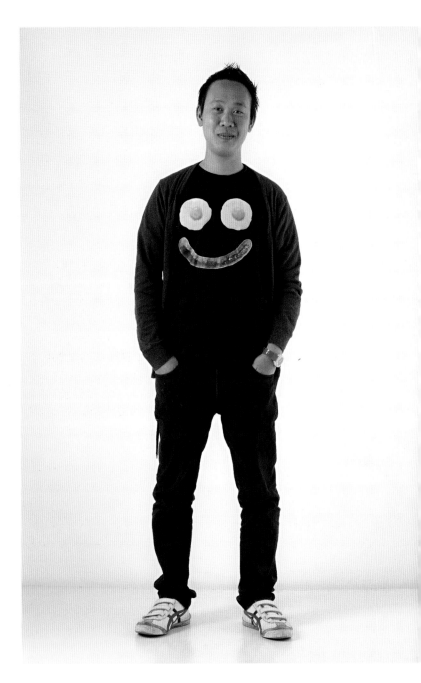

Simon Phinith

ge: 29

he tattoo on my left forearm is a double bass clef, because I believe that the bass
 the soul of music. The sleeve on my right arm is an artist's interpretation of an
bum cover from my favourite band. I know it sounds cheesy but I think everything
ed up perfectly at the right time for me. I have always wanted this album cover.
is from the 20th anniversary cover of Sublime's 'Everything Under the Sun'.
he two fish on the cover are so perfect for me too, as I am a Pisces. The artist
ho did my right forearm tattoo is an artist I have known about for a while. I read
lot about him back home in Australia. I happened one day to go to a tattoo
rlour (Family Business) and a mate of mine showed me a book from an artist he
ought I would like. It happened to be the artist Noon. His work is really me —
ally childish yet dark at the same time and big on patterns and lines. The next
ttoo I am currently working on is a sound wave. I am trying to convert the song
Vhat a Wonderful World' by Louis Armstrong into sound wave format and want
across my calves. I have been to a few places and no one wanted to do it as the
es of a sound wave are too close, but I am getting nearer to what could be done.
n also planning to get some writing on my body — I just have to find the right font.

ft forearm Andrea | **Right forearm** Noon

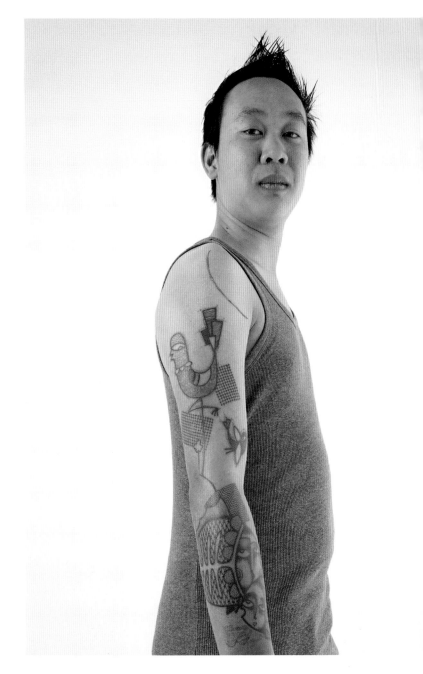

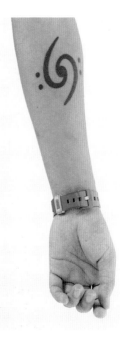

141

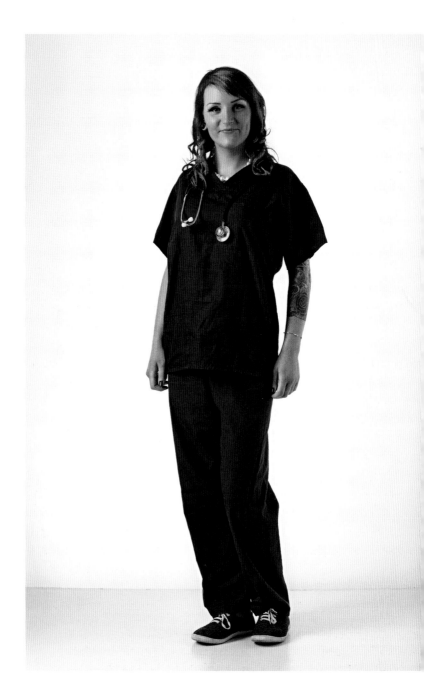

Dani P

ge: 26

n a surgical nurse in a private hospital, and a mother of one. I have always been
to modification. I got my first non-ear piercing (navel) at 13 and got tattooed at
4. Big mistakes, clearly! But at that age you think you know it all. I've gradually
ctified those mistakes, covering what tattoos I can with some real art. I am
assionate about tattooing and try to immerse myself in that world, attending as
any conventions as I can, collecting work from international artists and surrounding
yself with like-minded arty people. My tattoos are important to me as I feel
at when they are on display, I'm allowing people an insight to the real me.

y workplace is very conservative: I have to remove all piercings, hide my stretched
bes, wear long sleeves and I wear a short brown wig to adhere to uniform policy.
) it's almost as if I have two identities: the 'respectable' medical professional, and
anielle, the aspiring model and art collector. I ALWAYS have a tattoo project on
e go. At the moment I am forcing myself to get my gothic pirate ship finished on
y ribs, although it's taking me longer than usual! After that is finished I am having
portrait of my daughter on my thigh. And I'm currently drawing up ideas for my
her sleeve. I'm crazy about 1950s pin-up art so I'm sticking to that theme with
Gil Elvgren witch in a Hallowe'en style — jack-o-lanterns, candles, candy, etc.

ft bicep, right forearm Jeremiah Barba | **Left forearm, stomach, left and right**
lves Micky Hall | **Upper back** Chuck Willmott | **Left thigh** Daryl Dodge (Apprentice)
Right thigh Iker Ruiz aka 'Fucking Fat' | **Left and right feet** Sue at Chucks

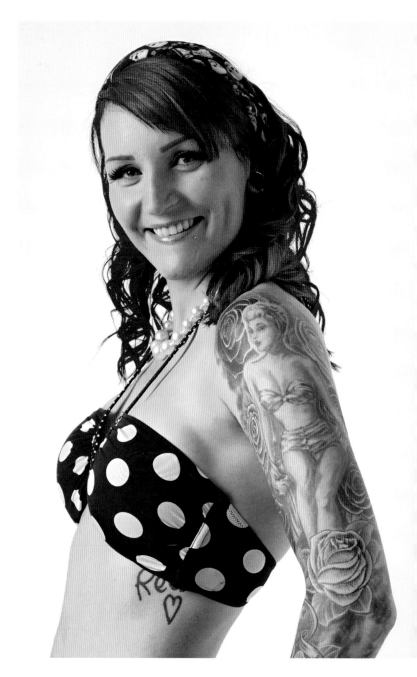

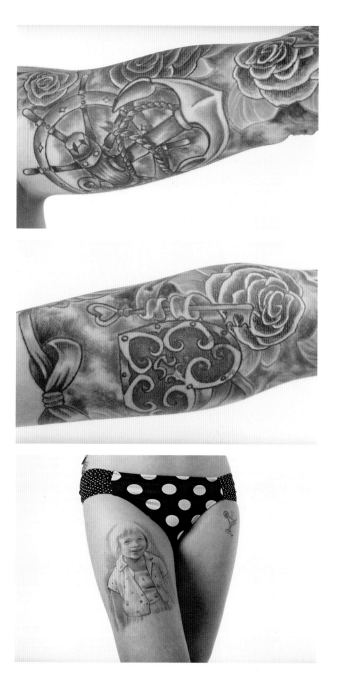

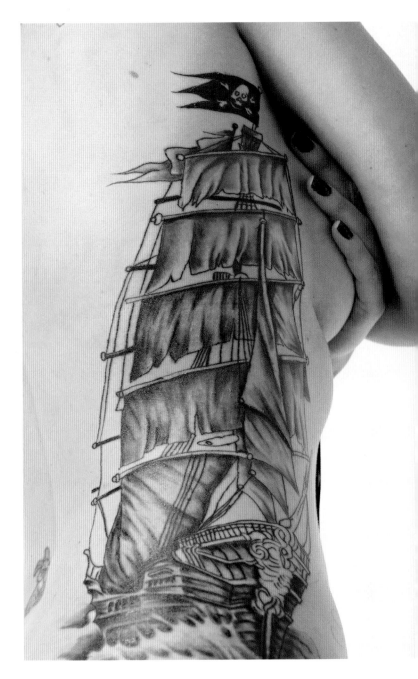

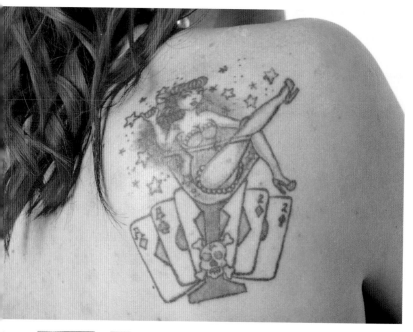

Hopefully my feet will get started later in the year — I'm planning to cover both in leopard print, one brown, one pink.

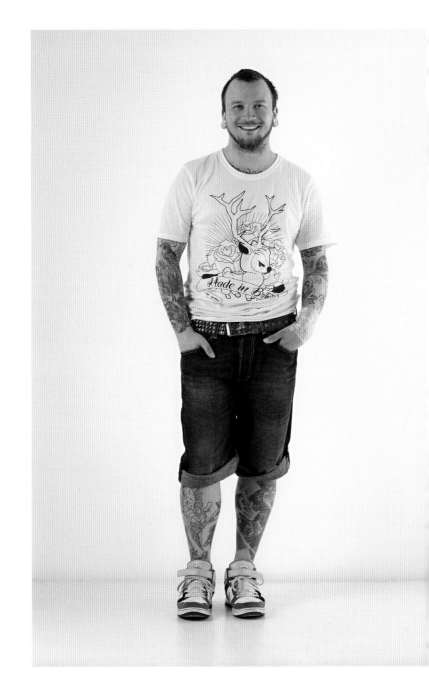

Andrew Shirley

Age: 30

I always wanted to get tattooed. Being into heavy metal and seeing bands like Sepultura, Machine Head and later on Madball, Sick Of It All and other punk, metal, hardcore and alternative bands with tattoos clearly in view in photos and at live gigs, it just reinforced my love for the art and I wanted some for myself. My first was the nautical star on the inside of my left calf which kind of happened on a whim when visiting a friend being tattooed. Less than a month or so after the first, I got another on the inside of my left leg and not long after that I started the Transformers' piece on my left calf. My tattoos have lots of meanings at different times. I have a few really personal tattoos and some that are just designs I like. People get too hung up on tattoos needing meaning. As much as how you take your coffee is a choice, so is getting tattooed. I'm hoping to get the rest of my sleeve finished by Tiny Miss Becca and to start something with Antony Flemming who is an amazing artist and so, so talented. Hopefully at some point I will get some more work by Davide Andreoli, Norm, Lu's Lips, Wez 4, Allison Manners and quite a few others. I love tattoos and I want to get as much work as I can from artists whose work I love.

Head, left bicep and forearm Aaron Hewitt | **Right bicep** Tiny Miss Becca | **Right forearm** Steve Byrne | **Left wrist** EJ Miles (Apprentice at The Pearl in Sheerness on Sea) | **Chest** Norm | **Upper back** Davide Andreoli | **Right thigh** Montana Blue | **Left calf** John Himmelstein | **Right calf** Various

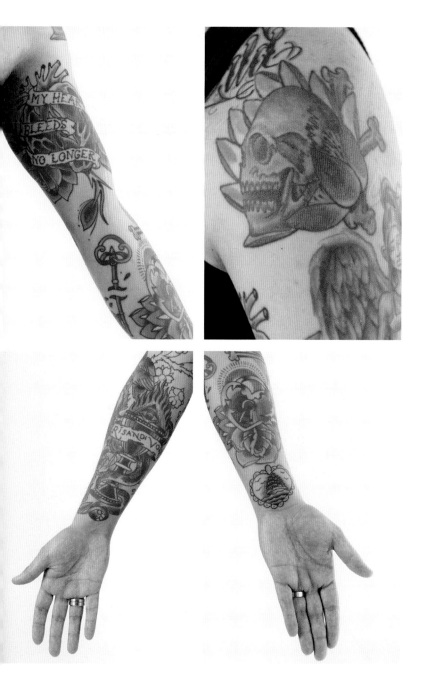

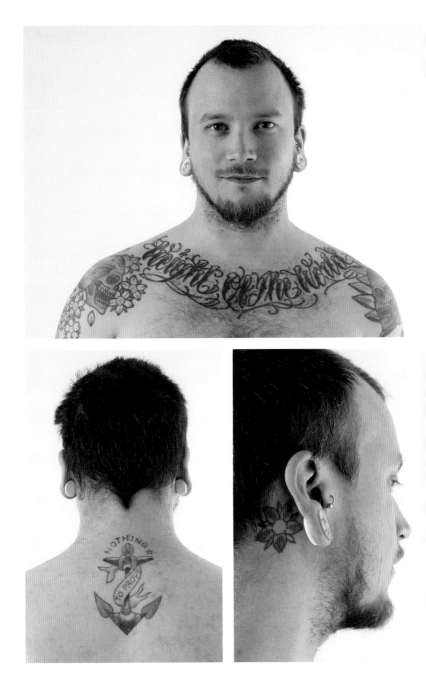

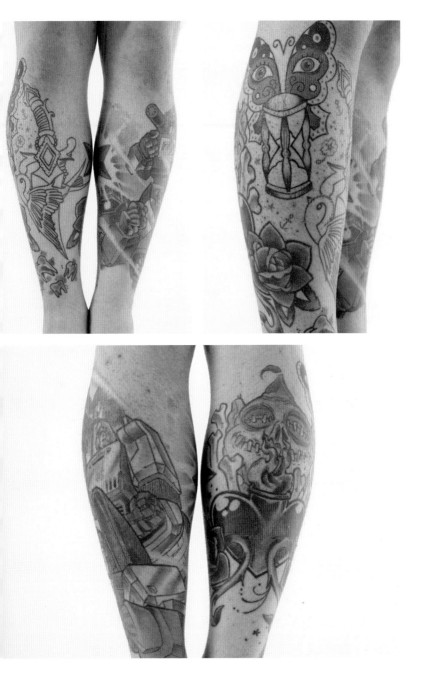

Claire Ruocco

ge: 37

s hard to think about their meaning until I think about their meaning…if that
akes any sense! If I'm honest I don't always think of them as tattoos as I feel like
ve accidently ended up with a new art collecting hobby over the years! It's very
uch the visual effect of the work that stands out for me and still messes with my
yes even now! I love my work very much and am fascinated by the reaction of
thers too. I'd much rather fork out my money using a needle and my own skin
an on something in a frame on the wall. Who knows, it could be my unexplored
eative side coming out or about me wanting to make my mark, to stand out
omehow, or just a touch of daredevil. I have a sneaky feeling it's all of the above!
would definitely miss them if I woke up and they weren't there! I'm excited about
y right arm, and continuing the Greek mythology story by a very talented artist
alled Remis Cizauskas who is based in Dublin. Medusa, Andromeda and a Kraken
ll join Perseus on Pegasus to complete the story from shoulder to wrist. Another
p to French Thomas for some more of his dots will probably be on the cards at
ome point…it never stops!

eft bicep and forearm, upper and lower back French Tomas at Into You | **Right
cep** Remis, Dublin

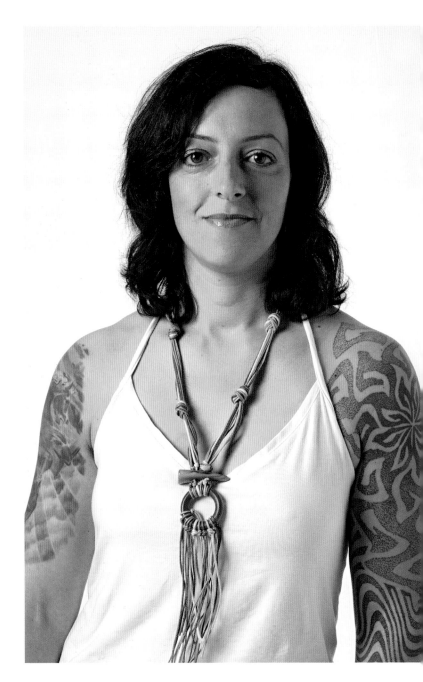

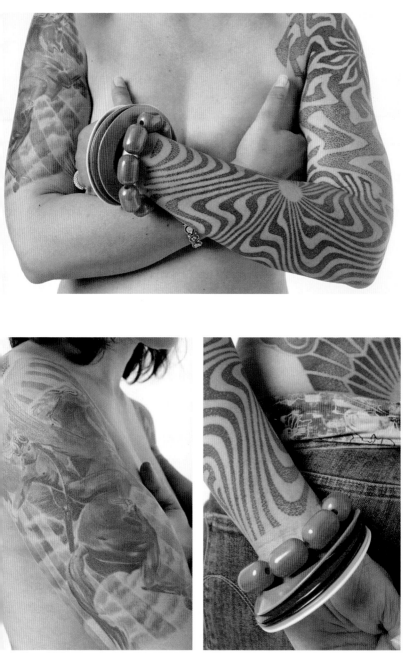

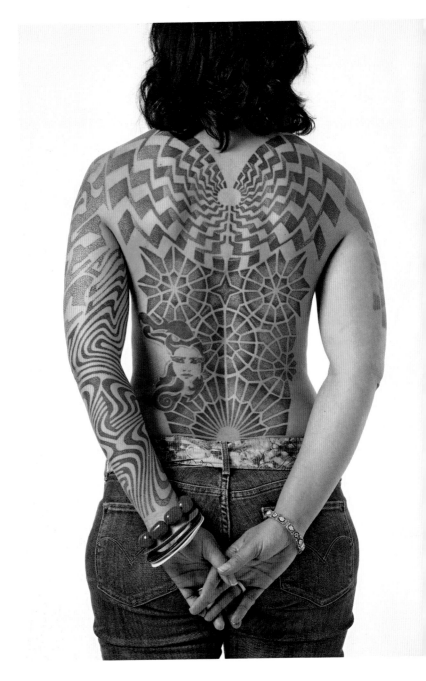

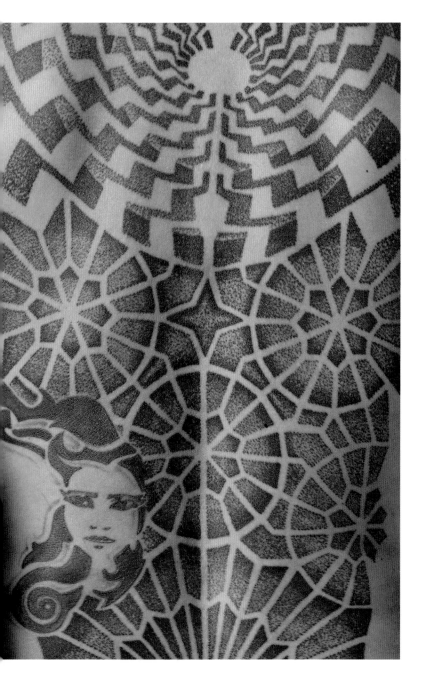

Lucrezia Testa Iannilli

Age: 33

My tattoo means a pure artistic project! They are old pictures from 1800 and 1930 and this type of woman is similar to my soul. But the concept is purely aesthetic. My next tattoo will take up my entire back and will be of an important painting by Girodet de Roussy-Trioson based on the novella by François de Chateaubriand, 'Atala'.

right arm Domiziano Cristopharo, Doctor Demenzia

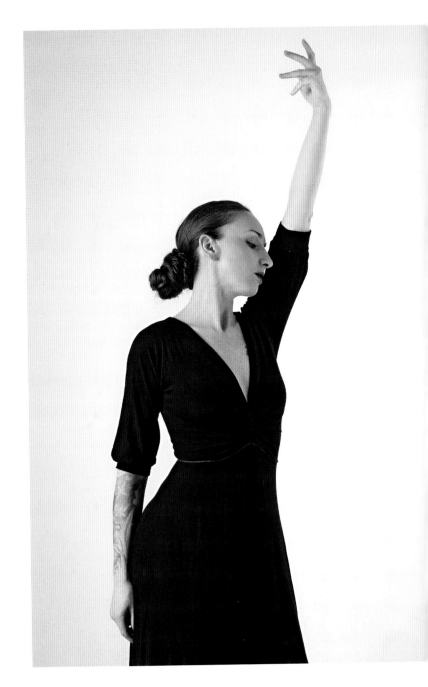

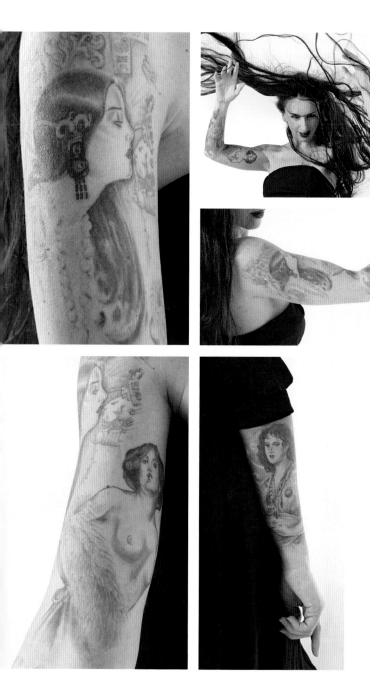

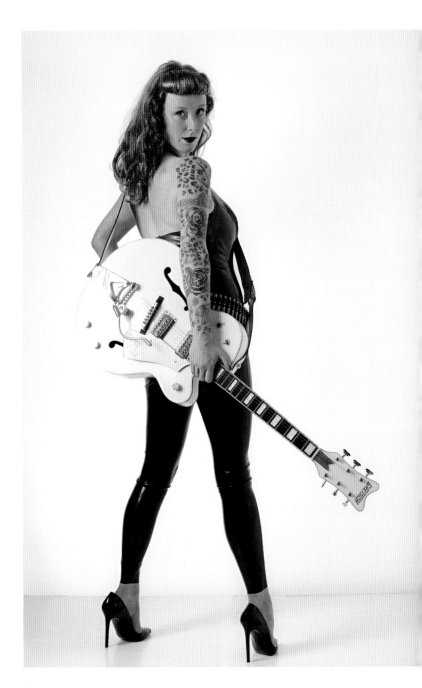

Kiria

Age: 27

My tattoos are varying fragments of my personality and life. I used to feel ashamed of my early tattoos — done on an angry adolescent whim — until recently, when I concluded that all the colours and pictures reflect moods and battles I have been through, some amazing and some devastating, that all help make up the bigger picture of myself. Now that I have a happier understanding of myself and my past, the latest addition is pink leopard-print skin I feel I have comfortably grown into. I believe the animal print is an exterior skin I adorn to keep me feeling strong, independent and courageous enough to take on anything this life throws at me. My next tattoo is going to be of an emperor penguin wearing a crown, with 'Queen of Jack' scrolled beneath it, symbolising my strength, loyal nature and love of playing rock 'n' roll, best accompanied by my faithful old friend Jack Daniels!

Head, right forearm, right hand Miss Betty Bones

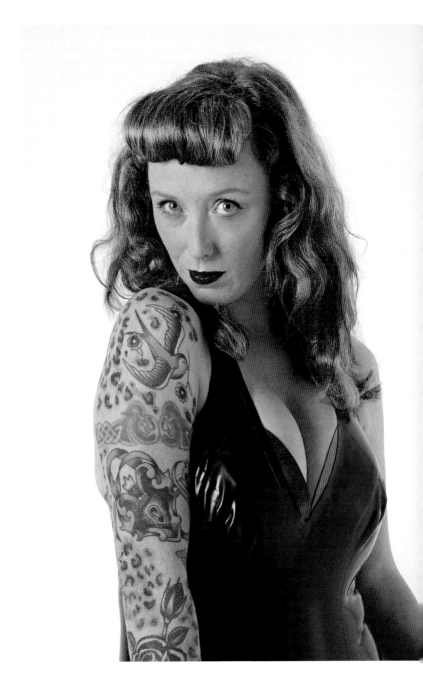

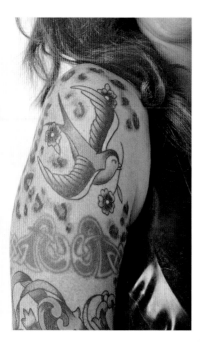

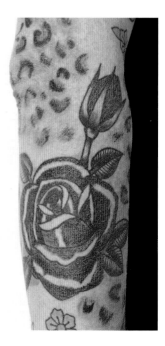

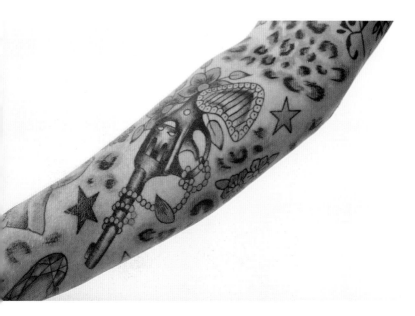

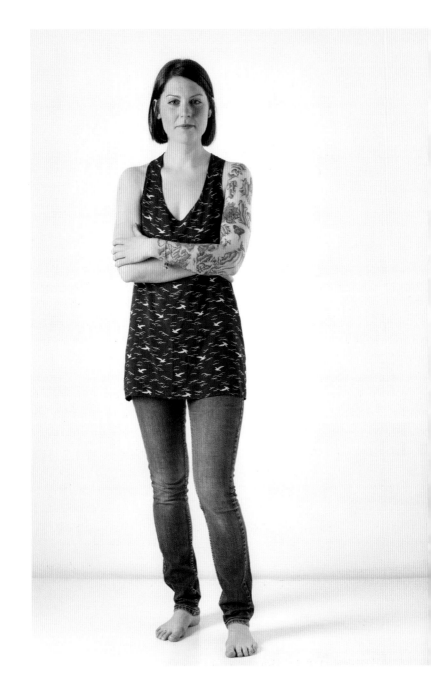

Amanda Burzio

Age: 24

My tattoos represent different emotions from different times in my life: they are an image of how I was feeling on the inside projected on the outside. They provoke reactions — not always good reactions — but it makes people ask questions and think outside the box, which to me is a great thing. It proves that there is still individuality. I try to design each piece I have with meaning. It's like reading a diary you kept as a child years after you have written the words. The butterflies on my back represent the double meanings and contrasting truths of today. In Japan a single butterfly was believed to represent the soul and two butterflies represented love. However a whole swarm of butterflies are seen as an omen. It's almost a reflection that even good things can have their dark side. I am currently designing a chest piece with Dusty, my tattooist. It will be a tale of two halves, a story of someone cynical and headstrong softening into someone who has finally shed the chore of carrying negative emotions. A heart in the centre, bandaged, with blood seeping through, to show something wounded but healing, with wings coming from either side. One wing will be feathered, fresh and new, wrapped around the front of the heart as if it is a hugging arm with teardrops/waterdrops falling from it; the other will be a replica of that wing but singed/burnt, being raised up and pulled away by a dove, to help it fly. Shaping it and forming the background will be autumn oak leaves, compact at one side and scattered at the other, almost like in passing the heart they've hit a burst of wind.

Left bicep and forearm, upper and lower back, right thigh Dusty

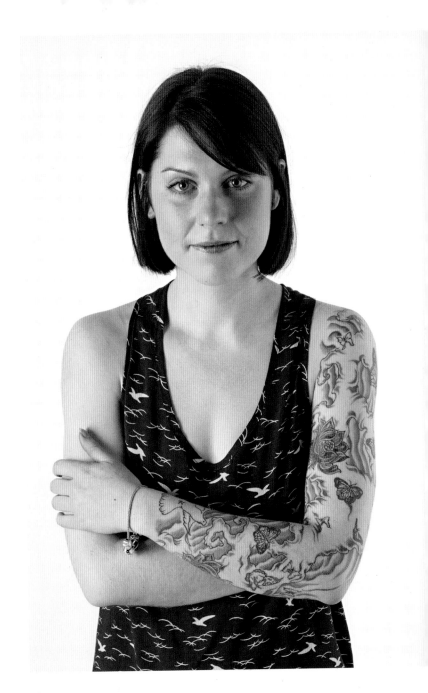

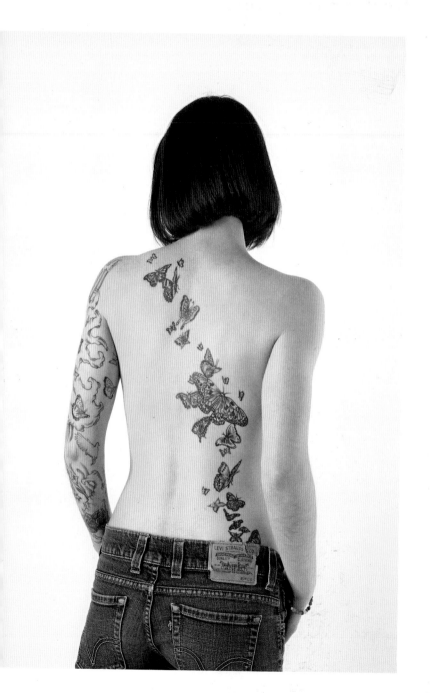

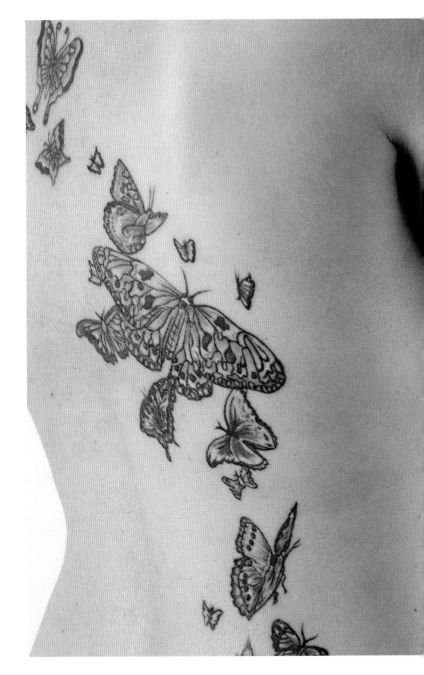

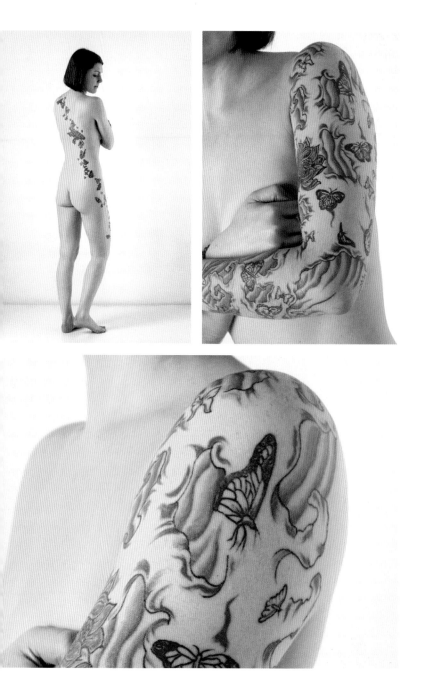

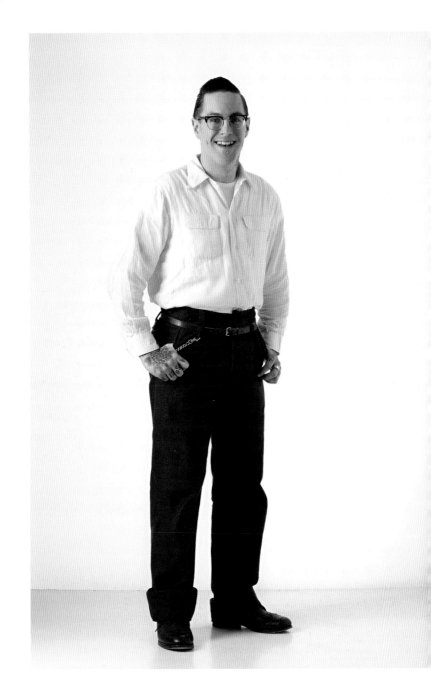

Dr Matthew Lodder

ge: 31

am a PhD-educated art historian. My doctoral thesis was on tattoos as art.
ind the very concept of tattoos having 'meaning' a problematic one. The framing
 this question — which presumes tattoos do have a meaning — encourages
e construction of a plausible narrative even for tattoos which might 'mean' very
tle in simple, direct terms. Also, asking the question this way negates the fact that
ven when a tattoo does have a meaning, that meaning may change over time,
 be obscure even to the person upon whose body it is tattooed. Some of them are,
most literally, meaningless as far as I'm concerned — the tattooists who produ-
ed them had more stake in their symbolic message than I did. A better question,
erhaps, is 'What does being tattooed mean to you?'. Being tattooed is an expression
 my own history, my passion for tattoos and my commitment to and love for the
t form. I'm a collector. In the immediate future, it's likely I'll acquire a few small
eces on my arm in the few remaining gaps, and also get a larger piece on my
omach. I'd like to embark upon getting a back piece sooner rather than later, too.

ead, left and right foot Becca Marsh I **Left neck** Tutti Serra I **Right neck** Simon Erl I
ft bicep Martin Clark I **Right bicep** Martin Clark. Bob Done. Steve Boltz.
arina Inoue I **Left and right forearms** Martin Clark. Alison Manners. Jack Mosher I
ft and right hands Peter Largergren. Drew Horner. Becca Marsh I **Chest** Martin
ark. Uncle Allan. Steve Byrne I **Stomach** Drew Horner I **Upper back** Stuart Cripwell
Right thigh Uncle Allan I **Left calf** Becca Marsh. Alison Manners I **Right calf** Adam
arton

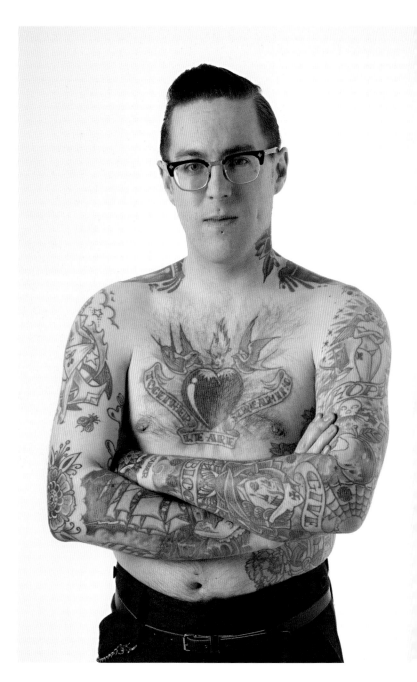

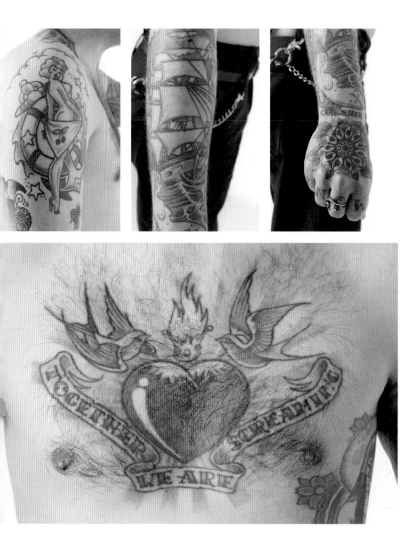

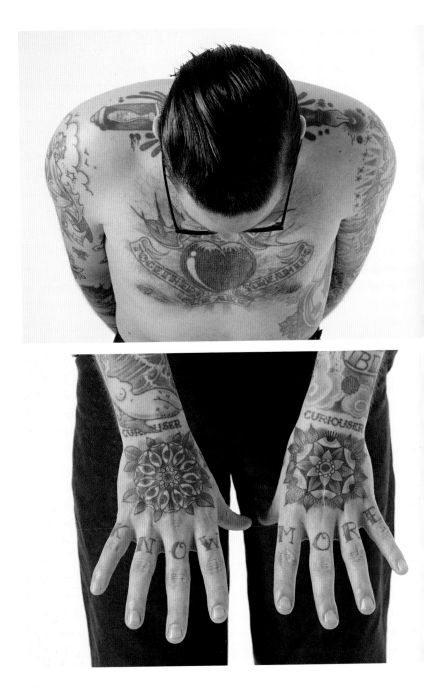

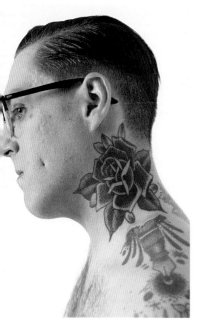

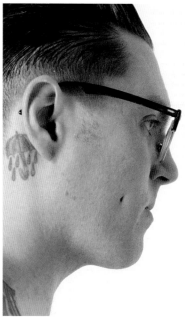

ometimes
cool tattoo is
ust a cool tattoo.

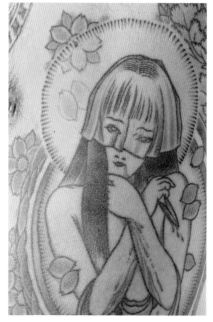

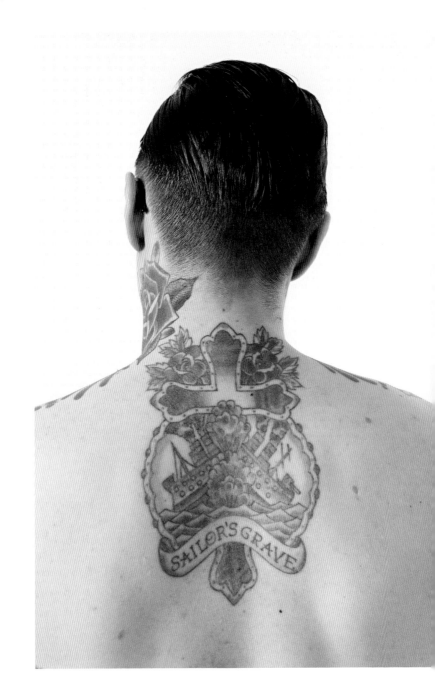

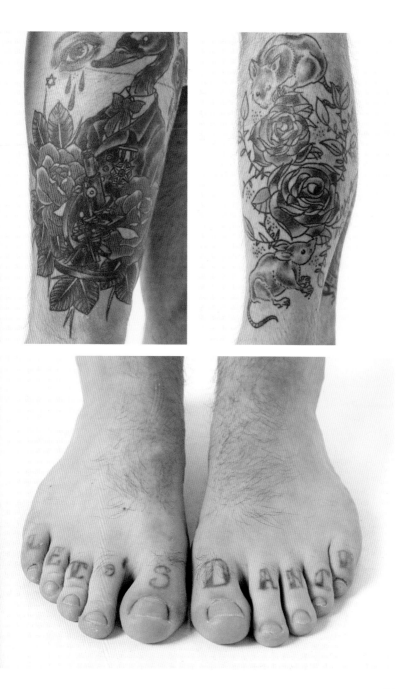

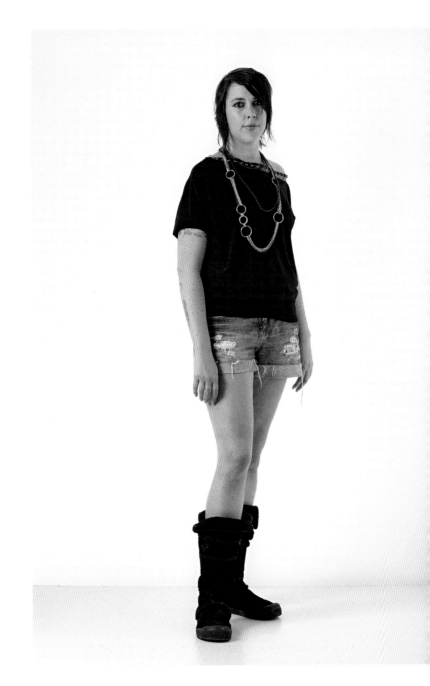

Amber

Age: 33

What my tattoos mean to me — tricky one.... I just love them. I love the individuality that they give me. Having designed quite a few of them myself I believe this makes them even more personal. I think my tattoos help to define the person I am. In truth I would now feel completely naked without them. They also give me a confidence that I feel I would not have without them. They are now an integral and massive part of my life. I hate the feeling of not having a session at the tattooist's booked into the diary. I also thoroughly enjoy the actual process of being tattooed. I think it can also help as a record of your life. I remember at what age each individual tattoo was done and what was happening in my life around that time. Where the tattoos are missing, often the memory is as well.

Head, left and right biceps, chest, stomach, upper and lower back, left and right thigh Skelly | **Left and right forearm** Jeff Ortega

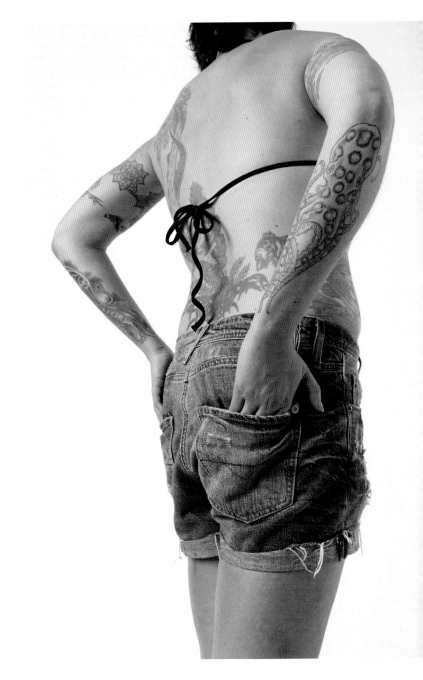

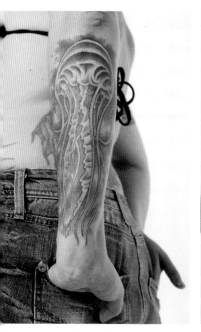

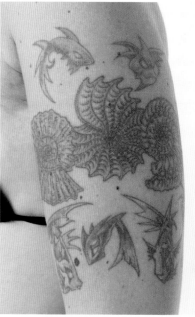

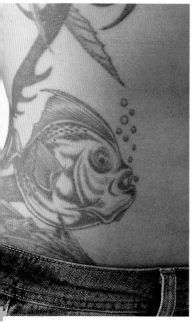

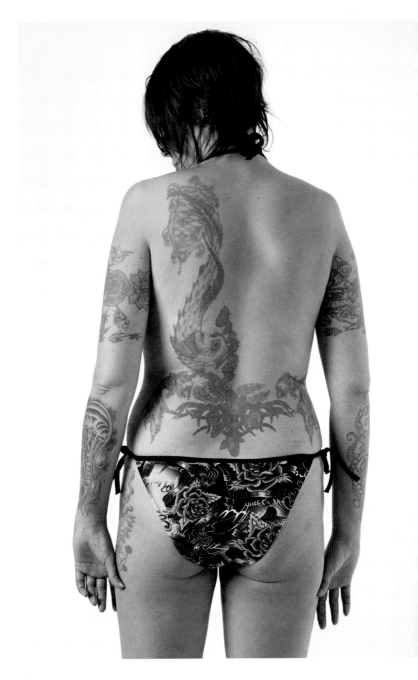

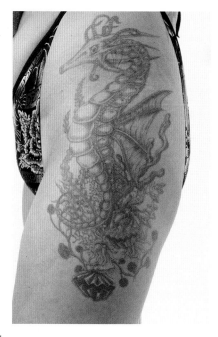

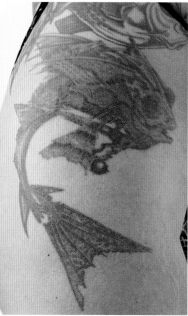

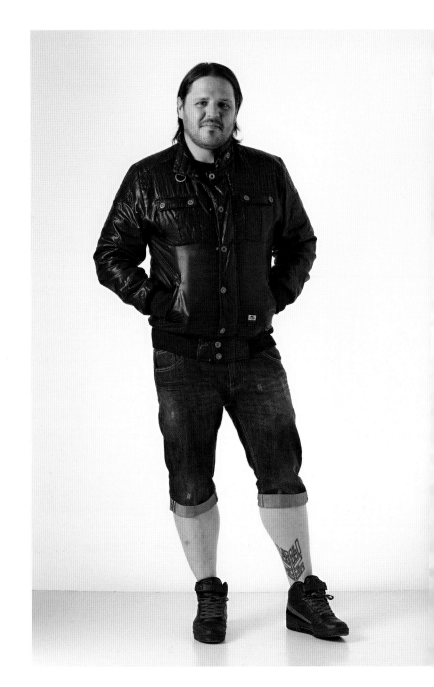

Pablo Rodriguez

Age: 35

've been drawing and painting since the first time I grabbed a pencil, so I got interested in tattoos at a very early stage. I come from a small town in Spain, where tattoos at that time weren't seen positively. But I never cared about that, I just wanted to get inked. My Koi fish represents perseverance in adversity and strength of purpose. Life ain't always been easy, but I try to be motivated and determined. At some point I decided I didn't want to work for a company anymore and that I had to do what I always wanted to do so I'm currently fighting to become a tattoo artist myself. I have a tattoo of a tattoo machine, meaning when I decide to go for it, my determination and motivation is big. I also have an old school tattoo of a shark as a tribute to all the people that made this great art possible in the old days. I've got my grandmother's surname tattooed near my heart. I also have a tattoo of a red star. I always say that it's the red Communist star: I am not really a Communist. Then I've got my own logo that I designed for myself. It took me ages to come up with a definitive one but I got it right eventually. And finally we get to my '2000 A.D.' sleeve. I've been always a massive fan of comic books. I love them all but I got deeply fascinated with Judge Dredd and his nemesis Judge Death. My next projects are to complete both my arms and then get both my sides and ribs done as well.

I've got some other tattoos made by other artists, but my most amazing work is done entirely by Mirek Stotker. **Head, right bicep, left and right forearms** Mirek Stotker

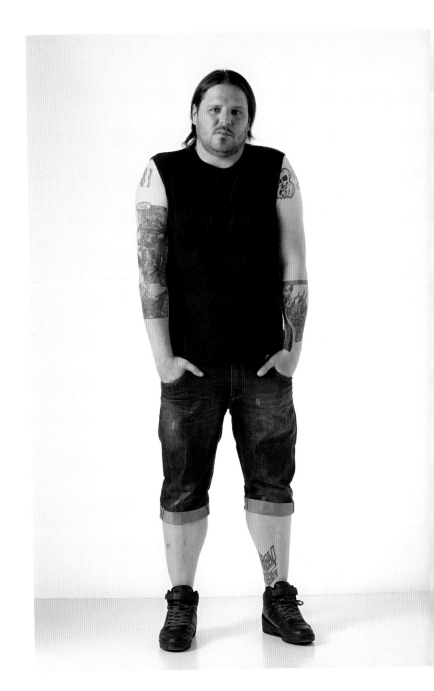

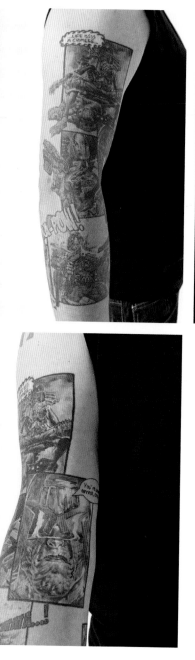

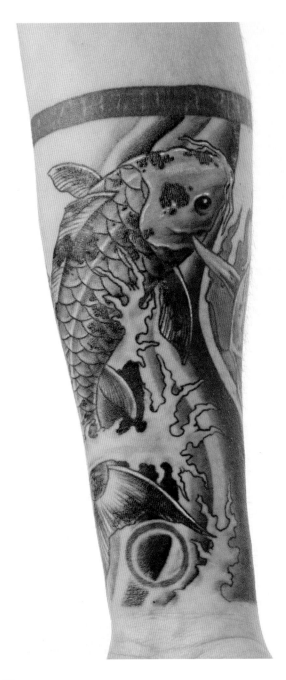

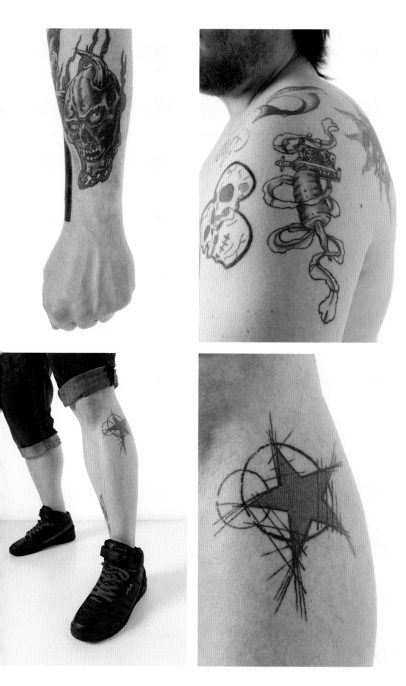

Hayley Hayes

ge: 31

)art from some bits, mainly my ink is for decoration. As an artist,
 me it's a natural thing to use my body as a canvas: why have blank,
interesting skin when you can adorn it with colour and pattern?
ckily, out of my fairly conservative upbringing, I lovingly acquired
ough freedom for thought. With that and some insights into the history
 the tattoo, I shed any socially inherited pre-judgements I had of
's indigenous art form. Included in my work are words by Khalil Gibran
d a Tibetan bell. The content is mostly Japanese based. My next
too will be completing my legs. I have no plans for my front as yet.

ft and right bicep, left and right forearms Aaron Della Vedova I **Upper**
ck Glyn Foster I **Lower back** Alex Binne I **Left thigh and calf** Jon Nott I
ght thigh Nikole Lowe I **Right calf and foot** Xed Le Head I **Left foot** George
he I **Tibetan Bell, top left side** Cooper at Guru Tattoo

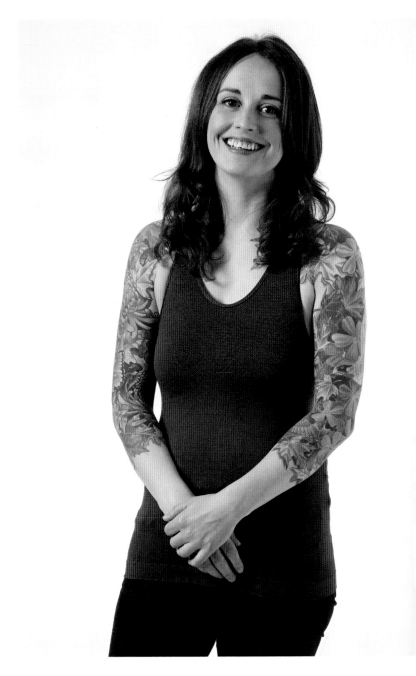

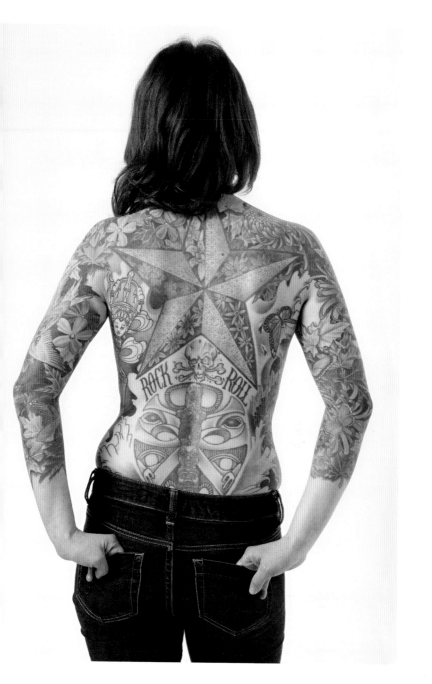

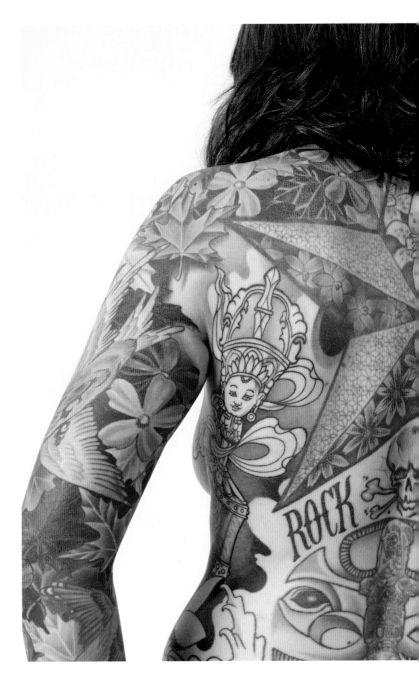

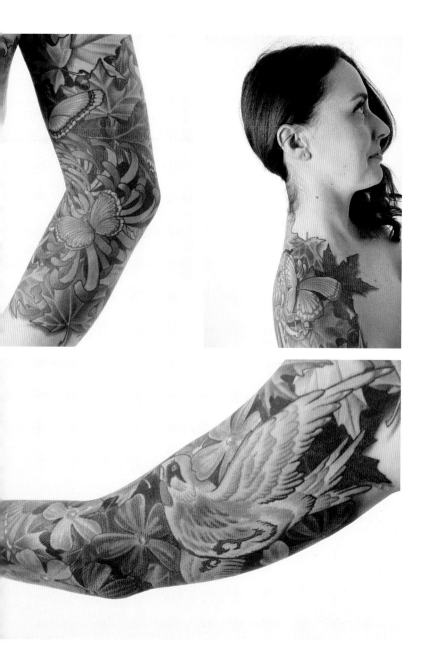

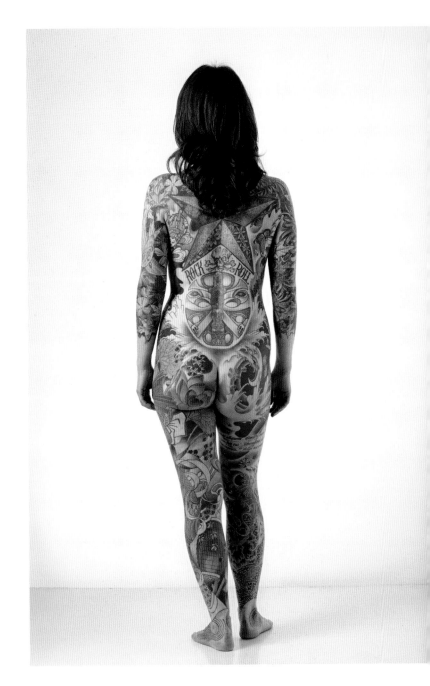

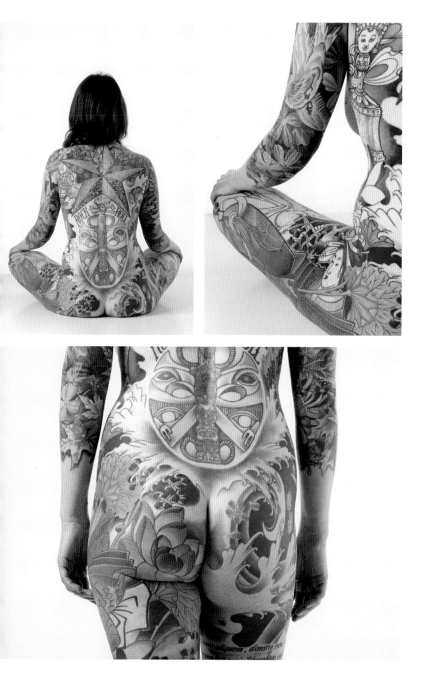

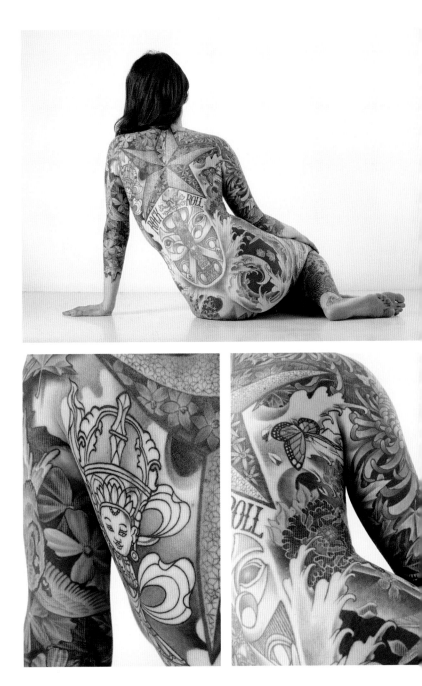

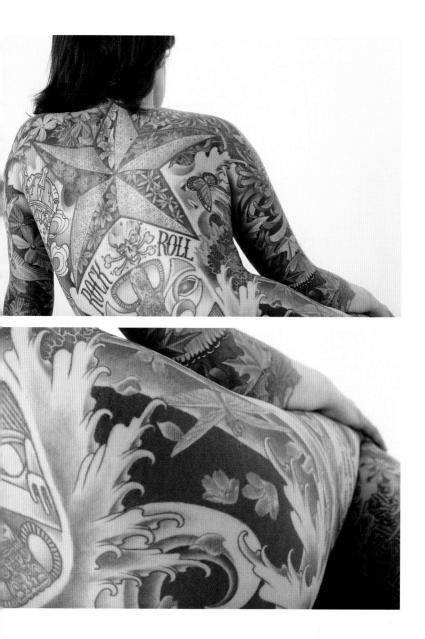

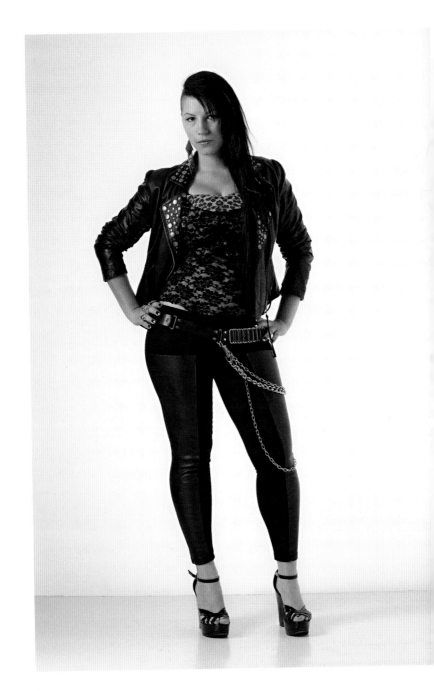

VJ Von Art

Age: 26

All my tattoos are drawn and designed by myself and the work is done by my mates. As an artist I have always admired all forms of art and have experimented with different materials and surfaces to express myself. I always tried to recreate myself in the way I look and live my life through different mediums: like clothes, hair and now tattoos. I started designing my own tattoos as I wanted them to be unique and reflect who I am and what my art is all about. I didn't want it to be a fashion statement or a design from a book found in a tattoo shop. In a way my tattoos are my artist CV as well as yet another way to make art. My skin is my canvas and tattoos are a reflection of major events in my life. I want to learn how to do tattoos so I can tattoo my own designs on other people rather than just design them and give it to other tattoo artists to do. My next tattoo will be on both of my feet. I have a design of a skull that I want to get done. 'The good and the bad one' will be a reflection of my good side and the other of my negative nature. The biggest project I am drawing up at the moment is a tattoo design that will go onto my back and will take up half of my upper back and shoulder. It will be an Art Deco-style female face done in a modern fashion sketch style with peacock feathers coming out of her hair and mechanical parts — something like that.

Left hand Tao at Tattoo Time Studio, Harrow-on-the-Hill | **Right hand, stomach** Adem's Tattoos | **Right foot** homemade

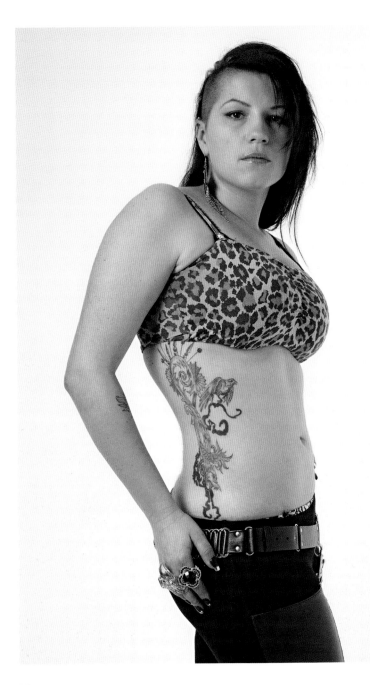

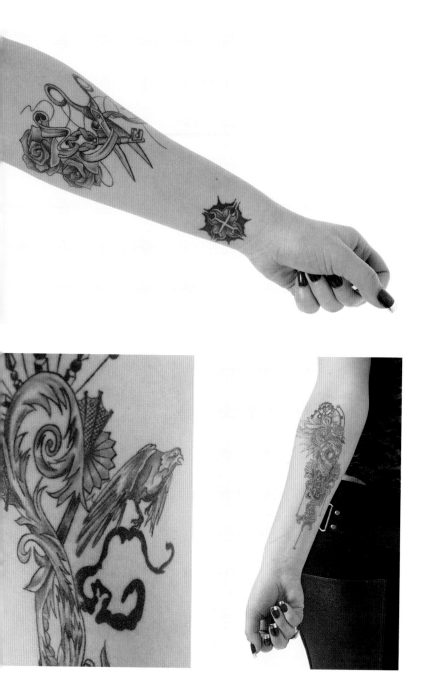

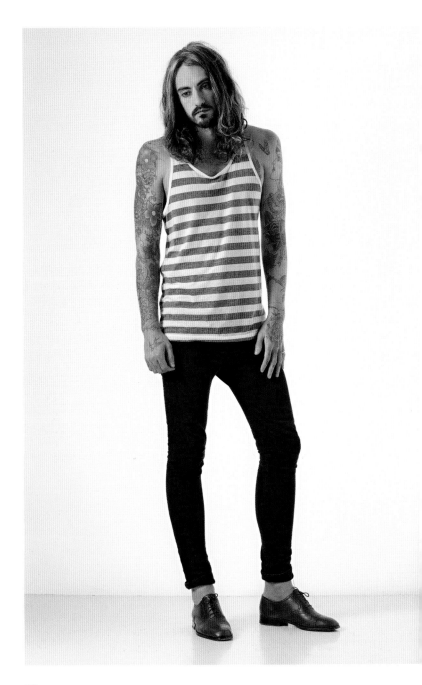

Adam J. Evans

ge: 26

ave a biblical quote on my left bicep which was for my nan who passed away.
e used to wear a pendant with said quote inscribed on it. I'm not personally at all
igious, but y'know. Unfortunately it turns out this same quote is connected to
coholics Anonymous, which I only found out recently. I work as a graphic designer
r Poke and operate under Ordinary (www.ordinarydesigns.com). That is why I have
rdinary' across my fingers on my right hand. The majority I guess are just style
er substance. I have quite a heavy floral theme going on which I generally thought
s the most organic use of colour I could have, as well as being a timeless design.
y next appointment will just be to fill up a few gaps and polish off a few things.
on't have any current plans for anything in particular; I'll see what pops into my
ad over the next couple of months. I want to have something on my foot/ankle
ea but something could be anything, possibly in a pirate vein.

ft and right neck, left and right biceps, left and right hands, chest Henry Hate
Prick, London I **Left and right forearms** The Shop, Lincoln I **Upper back** Living
lour, Lincoln

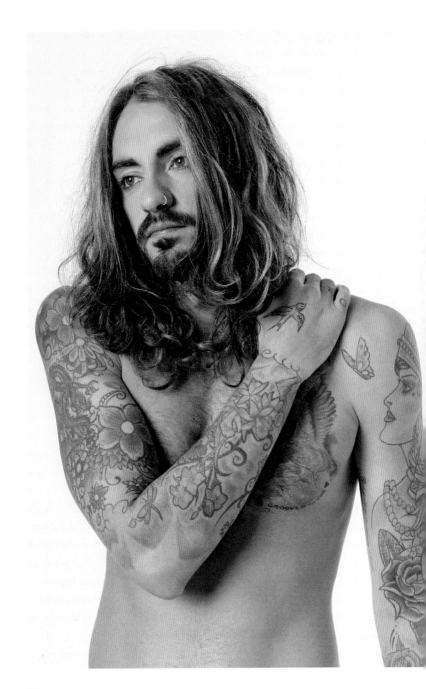

I can't imagine flowers
are ever going to be
offensive even when
I am an old man
throwing darts from my
wheelchair.

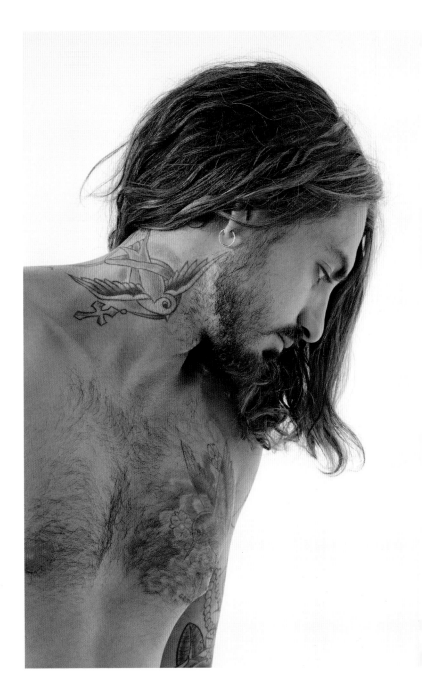

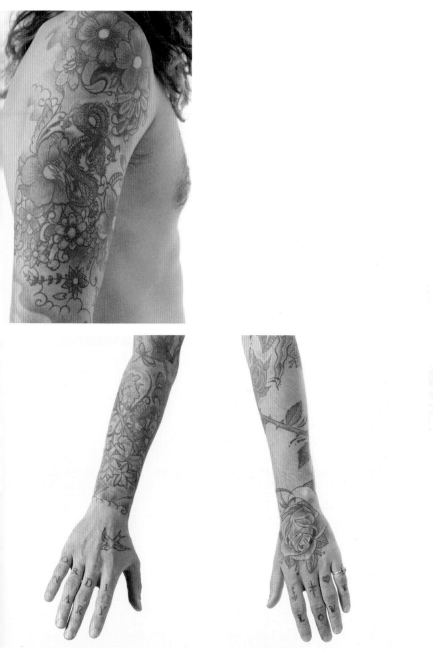

Rafe G

Age: 31

My tattoos mean everything to me, because they are (on) me! Obviously they all have personal meanings to me...from memories, beliefs, principles, reminders of past experiences to fun and things that I just like (art). Let's face it, art's a personal thing at the end of the day. It's all subjective to our own taste. I've always had an interest in tattooing and its tradition, mixed with skill. It's an art. And to be a part of it by having a tattooist create a piece of art, to live on my skin, is kind of special to me. I'm just the lucky canvas that gets to show off their work. I'm not sure at the moment what tattoo I'm gonna get next, kind of depends on what and where; then there's finding the artist who has the time to do it. I've more ideas bouncing around in my head of future pieces and artists I'd like to 'commission' for the work. One in particular is Jun Cha, from LA. An amazing young artist with too much talent and skill.

Henry Hate has done the majority of my work in the last four years, with other artists doing various pieces prior to that. **Left and right neck, right bicep and forearm, right hand, chest, stomach, right calf** Henry Hate I **Left bicep and forearm** Zoe Lazo I **Left hand** Mills I **Left calf** Gemma Pariente

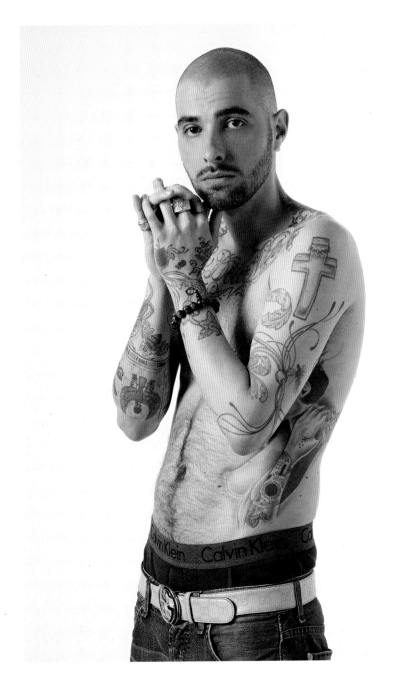

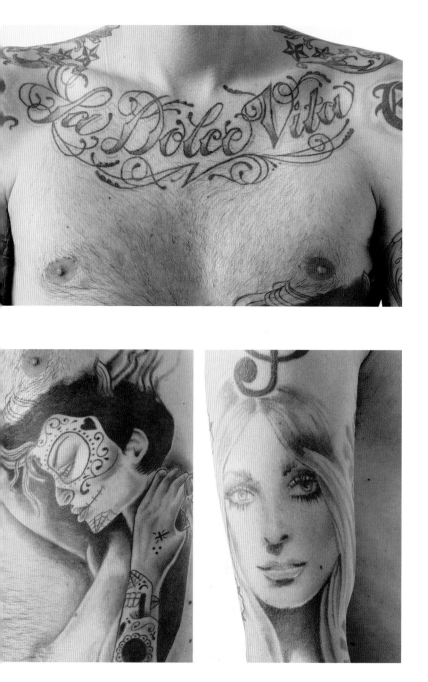

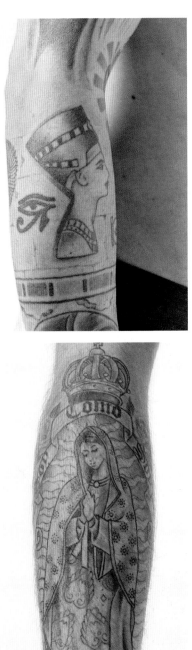

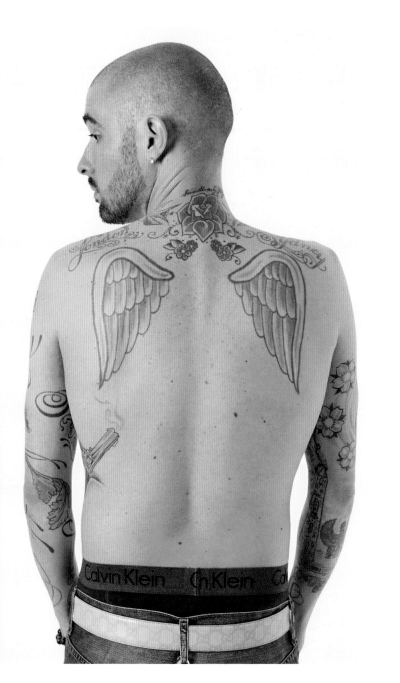

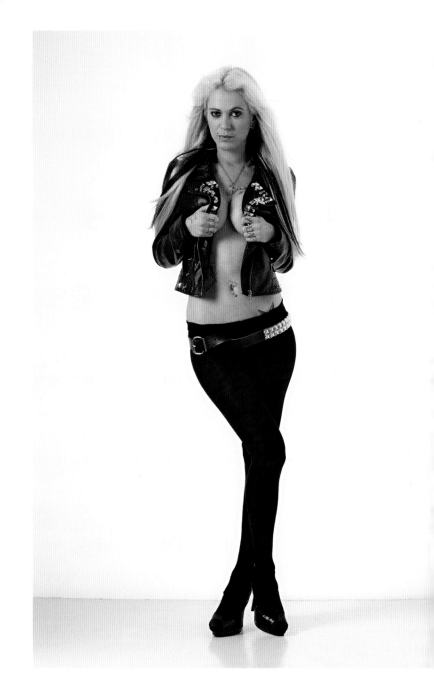

Steph Wayne

Age: 22

I've always been creative and into art, so I like the idea of having permanent art on my skin. I think your skin is like a canvas which you can enhance in any way you wish. I think it is a balance of having things with some meaning or some idea behind them and making them visually effective, as it is body art and ultimately tattoos are there to be looked at and appreciated. I also find some comfort in the fact that they are so permanent in a world which is so transient. The one I get asked about the most is my tattoo of Lolo Ferrari. People assume I want to look like her, but that isn't the case. I had it done for several reasons. On a visual level she's amazing — she is simultaneously beautiful and grotesque. She is also a warning to me of what happens when you do things in excess. It is also my little salute to a woman who spent her life wanting to be beautiful and loved. I think she would have liked it. I'm currently having work done on the lower side of my right arm — all fish and shells and underwater things. I'm planning on having almost two half-sleeves on my lower right arm and upper left arm and then perhaps some things done on my back. I don't plan that far in advance: I'm quite impulsive, and I'll wake up with an idea and then go get it done. I've found that the more you have the more careful you have to be about planning and linking them all together.

Many of my tattoos were done in Spain over the last few years. I do not recall the names of the artists. My most recent tattoos, on my right arm, have been done by Allan Graves and Andrew of Haunted Tattoos, London.

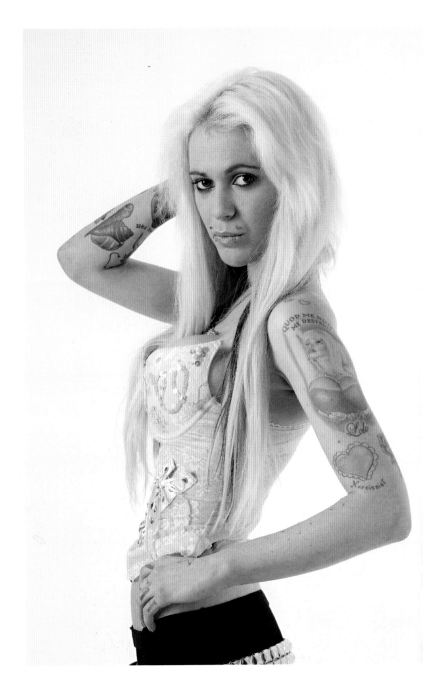

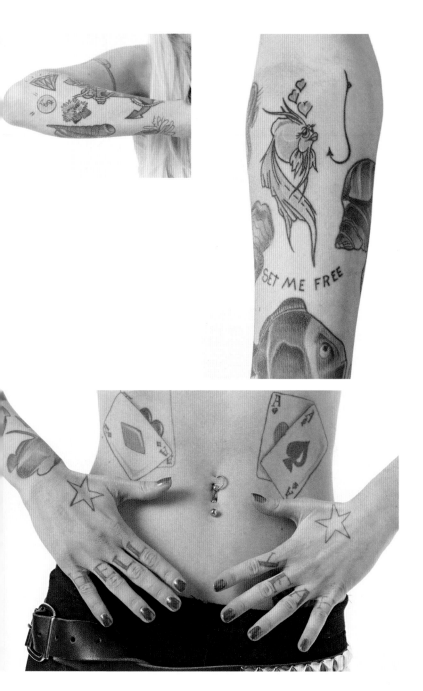

SET ME FREE

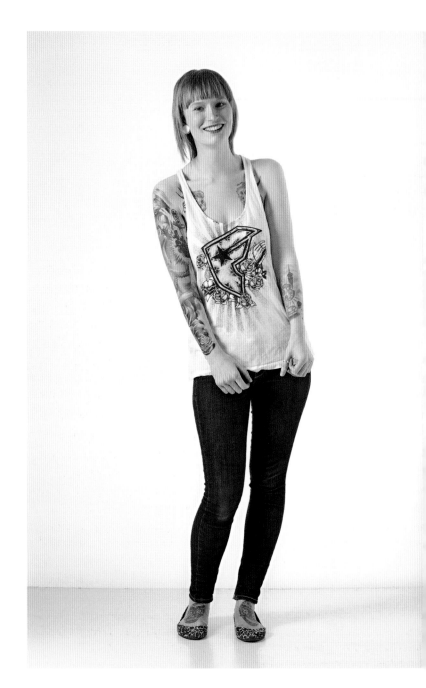

Coral Davies

e: 22

y tattoos mean a huge amount to me. They make me feel more comfortable in
y own skin. Each of one of my tats has a special meaning to me. Ankle wings
ere the first tattoos I ever got when I was 18. Stars on my lower back were
mething I got done with my best friend Sarah. My Vegas tattoo on my left lower
m I got to celebrate the first holiday I ever took with my best mates Alex and
cqueline. My chest and right sleeve and feet represent my love of Shakespeare
d theatre, and the amount of years I dedicated to drama. Next I am going to
ish my 'Romeo and Juliet' sleeve! But after that I want to get a memorial tattoo
r my stepmum who died — she loved my tattoos and was always excited to see
nat I was getting next, so I know she would appreciate it. What got me into
tooing? I'm not sure, to be honest. I just know that I always thought people with
toos looked amazingly cool and I knew from quite a young age that's what
vanted on my body. The more tattoos I get the more relaxed as a person I become,
I can't see myself stopping anytime soon. Plus they are great conversation
rters and I have met some great people just from me going up to them or them
ming up to me to ask me about my artwork.

on't know the name of the man who did the stars on my back or wings on my ankles
they were random walk-in appointments when I was about 18. **Right bicep and
earm** Kamil Mocet I **Left forearm** Nathan Kostechko I **Chest** Luci Lou I **Stomach,
t and right feet** Andrew May I **Inside of lip** Lesley Chan

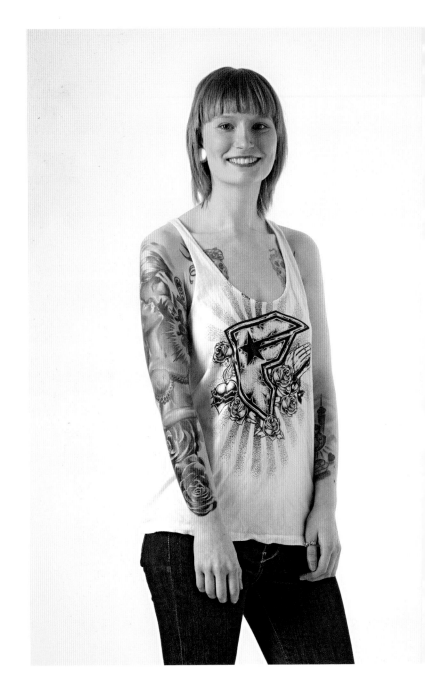

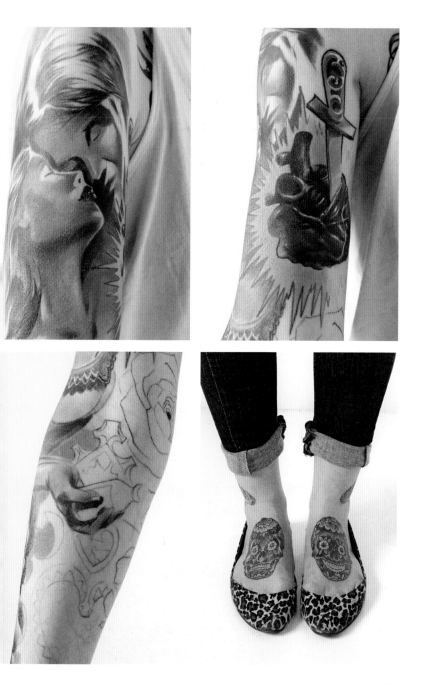

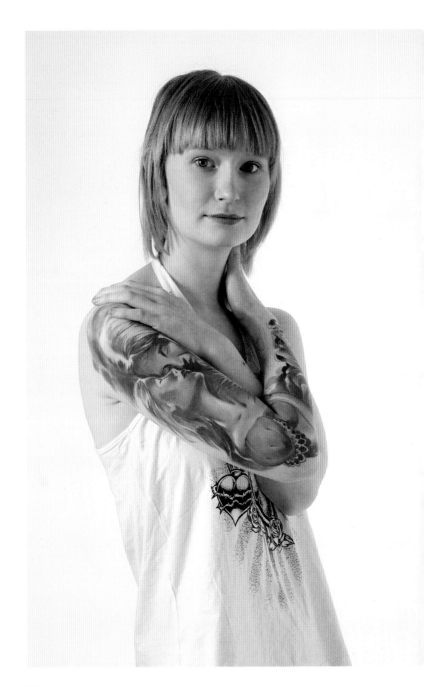

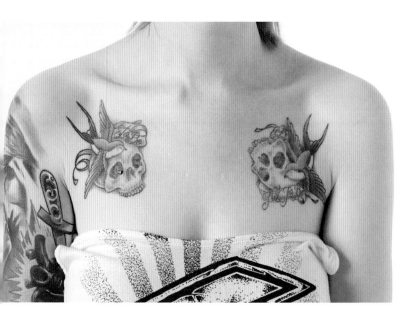

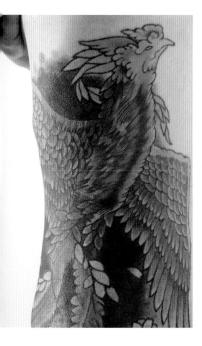

The phoenix on my side is the first (and hopefully last!) cover-up on my body and is there to remind me to think things through more carefully!

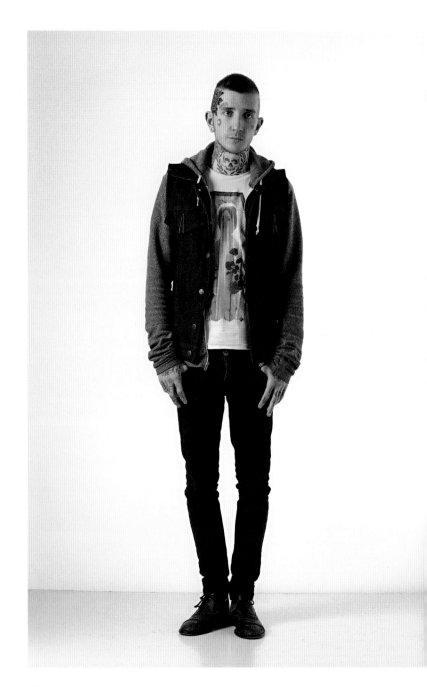

Justin O'Grady

Age: 21

I've managed to cover 90 per cent of my body. I have a mostly solid black arm cover-up, chest cover-up and face cover-up, all in the three years I've been getting tattooed. My tattoos are simply a collection of close friends' artwork. I've never been tattooed by an artist that I couldn't go to dinner with afterwards. It wouldn't feel right going to one of the studios that run like a production line. I remember enjoying the weekend I had or the events that took place around the time I got the tattoo rather than a meaning behind each piece. My next tattoo will be the final side of my head…followed by perhaps the top. That's somewhat risky as I don't think I call pull off the bald look with my build.

ead Sam Ricketts. Simon Erl. James Kiley | **Left and right neck, left thigh** James iley | **Right neck, left bicep, left hand, chest, upper and lower back, right foot** am Ricketts | **Right hand** Simon Erl | **Stomach** Tutti Serra | **Right thigh** James ley. Sam Ricketts | **Left calf** Tiny Miss Becca. Matty D'Arienzo | **Right calf** Pedro Soos

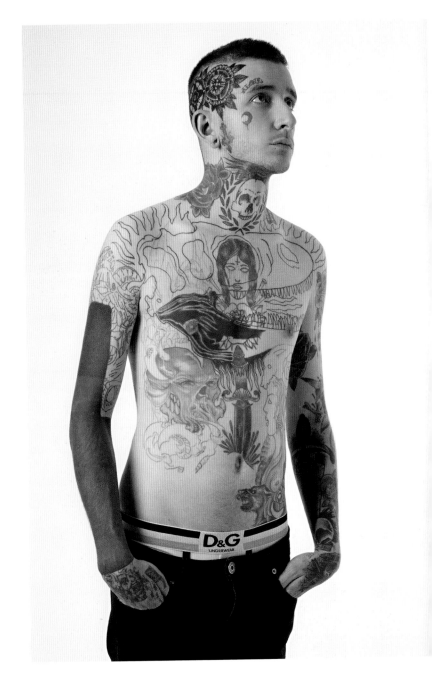

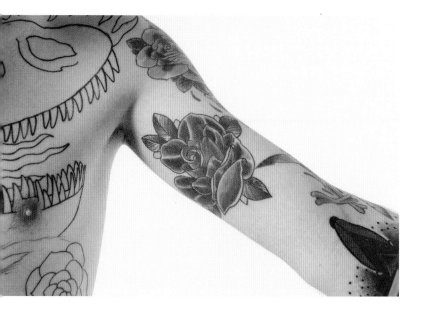

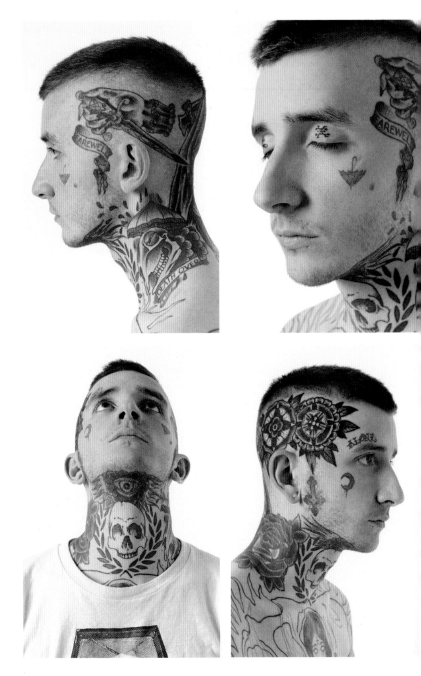

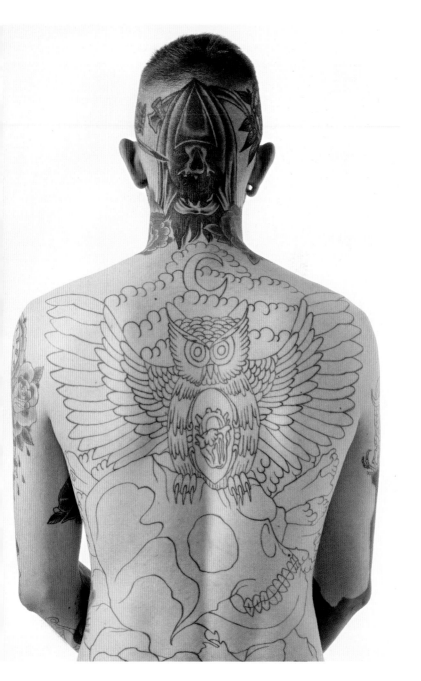

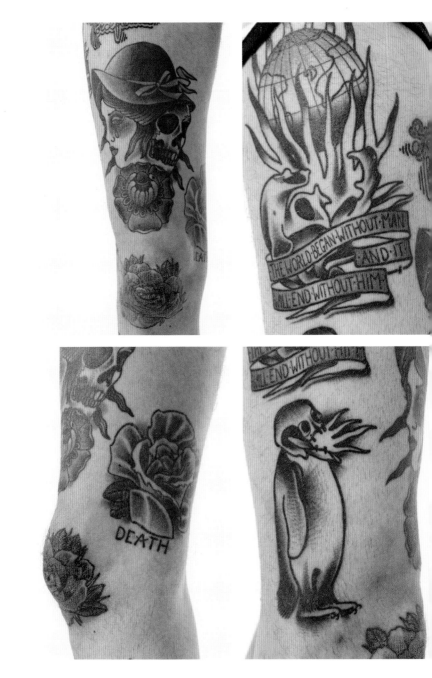

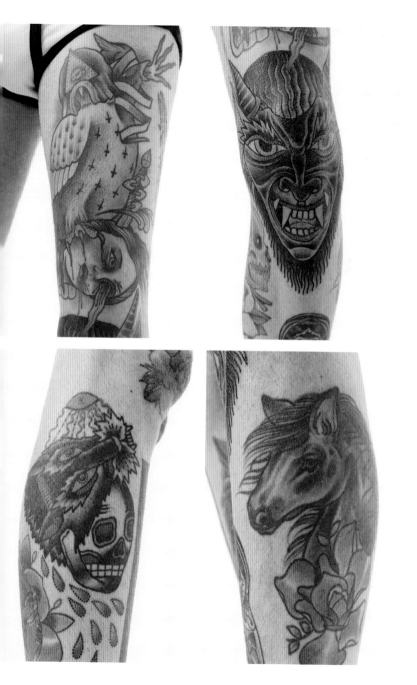

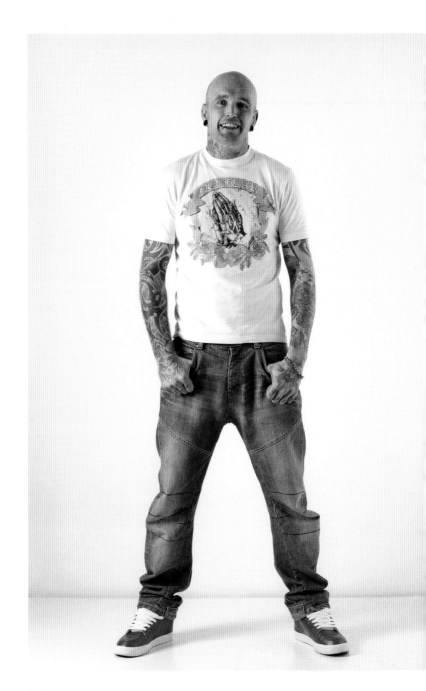

Alex Harvey

ge: 25

hat do my tats mean to me? I don't think any of my tats have a story
ehind them! I work in a tattoo shop so I'm always getting more done
one of the guys. I'm really into the whole body art thing. What's my
ext tattoo? Well I've had quite a few more since the photo shoot —
ished the back of my head and started my legs! Knee was really
inful! My next tats will be my armpits although I'm not sure what I'm
ving.

re's the names of the guys who have done work on me: Ray Alliston, John Moriarty,
uno Almeida, Gaz the Snail and Konrad Michalak.

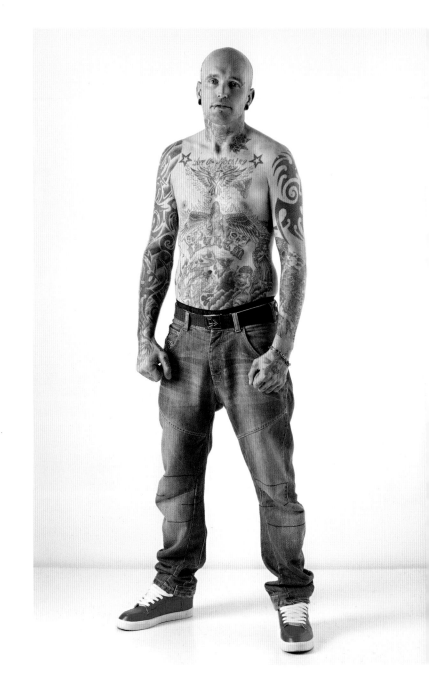

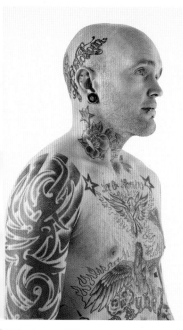

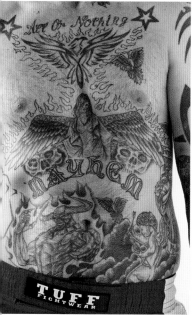

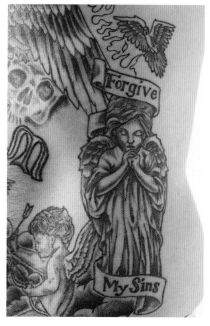

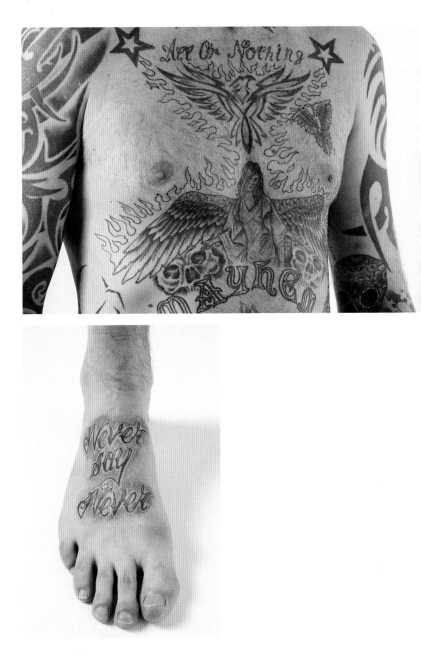

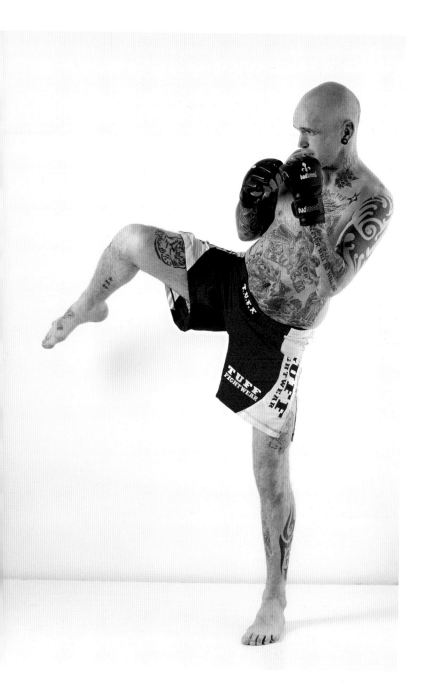

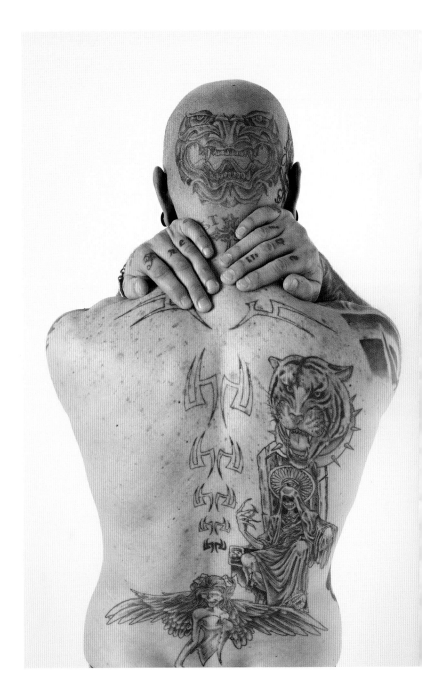

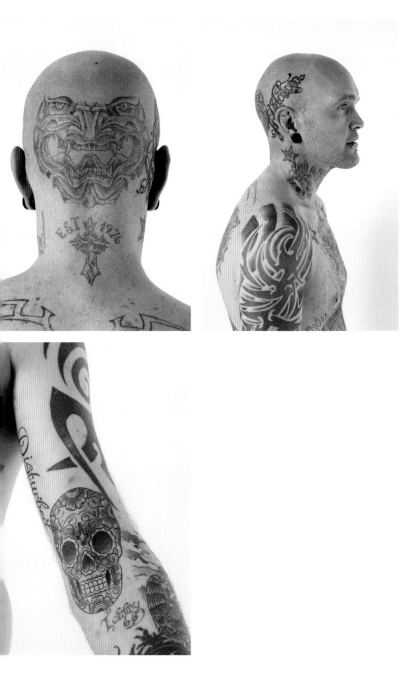

Lod

Age: 30

All my tattoos are very important to me. Each of them is an individual and all have an emotional relation to a time, a place or a person. Every one is special to me. My next one will be a big back piece in homage to my Spanish grandparents.

Left forearm Charlie Shazer | **Right forearm, lower back, left and right calves** Jay Jay Dallas | **Left thigh** Xavier Joubert | **Right thigh** Xavier Joubert. Ian Graves

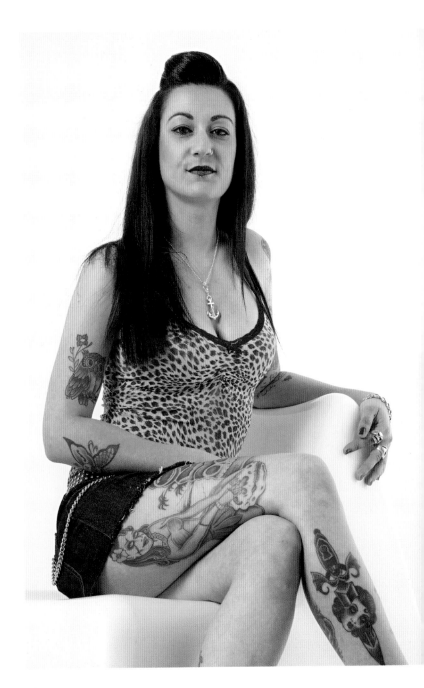

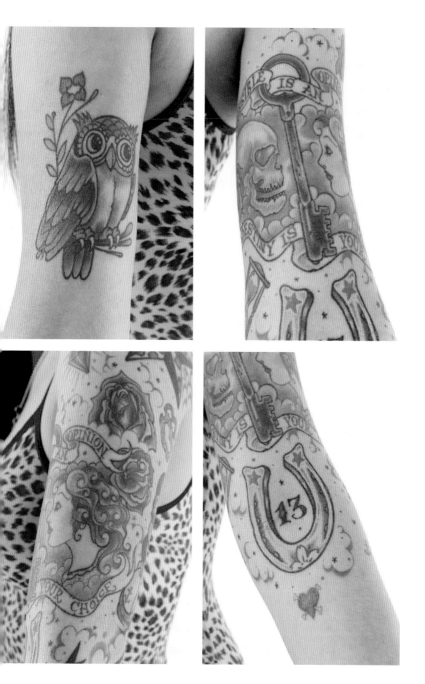

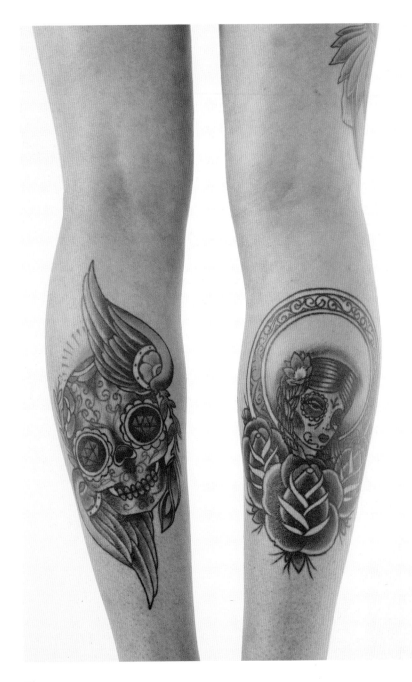

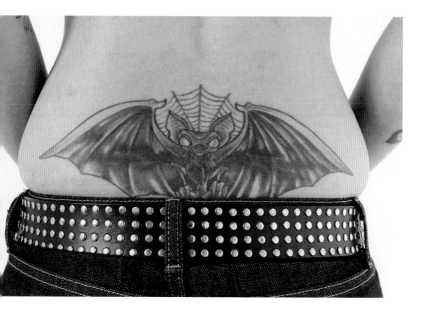

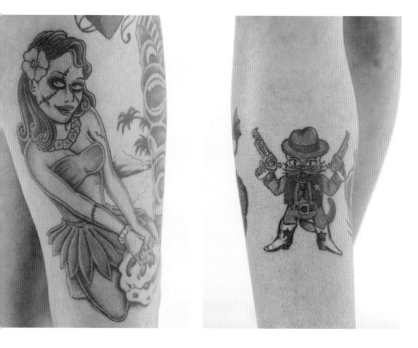

251

Graham Long

ge: 42

ly right arm sleeve came after 18 months of sourcing what I wanted and although
m now 42, it resembles my 40th birthday treat to myself. As my mother calls it,
's my 'CV in ink', as throughout the sleeve art I have representations of all the jobs
have had since leaving school back in 1985. Flowers: I worked at L Mills Nurseries
Creswick, which supplied New Covent Garden Market. Chequered flag: I love
otor sport, and back in the late 1980s I worked weekends at Brands Hatch.
pples: I then went to work at Orchards Shopping Centre as a security officer and
ter in centre admin. St George & the Dragon: I was promoted to Deputy Centre
anager and spent five years at St George's Shopping Centre. Comedy/tragedy
asks: for the last nine years I've worked at Woodville Halls Theatre. At work now
wear a suit and tie most days, so only get to show my tattoos off privately or
hen at the gym, where I train four nights a week. My next tattoo will hopefully
e a sleeve on my left arm. But I don't want to wait 40 years for that design,
I'm looking at other ideas for that.

ft bicep, upper back Bobby Swallows | **Right bicep and forearm** Richard Howrihane

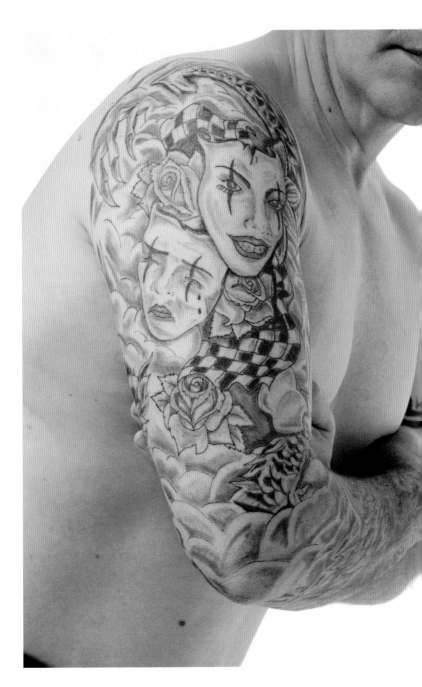

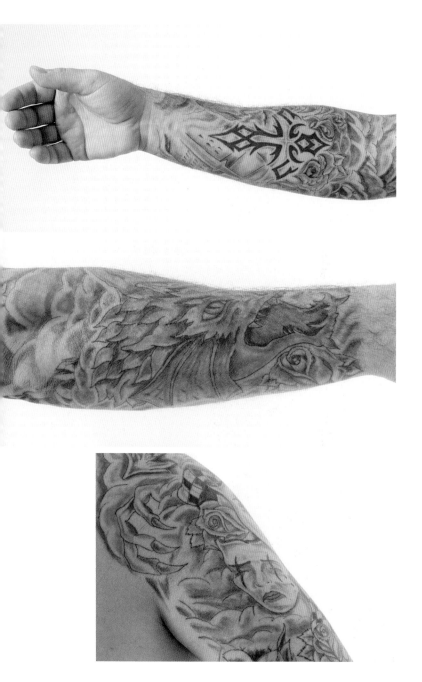

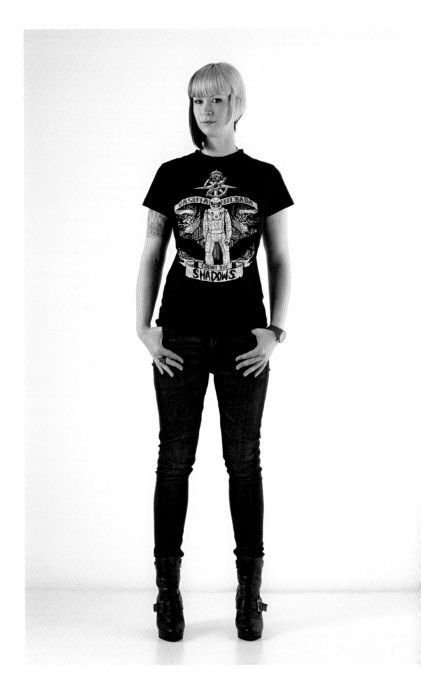

Cara Fielder

e: 27

tattoos are simply another representation of me, same as my haircut, clothes
the music I listen to. None of my tattoos represents people in my life but they
re all done at very significant times in my life, either when I was really happy,
lly struggling or recovering. To me, every one of my tattoos corresponds to
oint in my life that I will never forget...even if I wish I could. As for images on
skin, I like to see them as art (well, my later ones anyway!), but I feel a little
eper about the words, especially the script on my feet. It reads, 'Tears don't
tter much', which is a song from one of my favourite bands called Lucero.
t I also think of it as a really positive way to feel about pain. Get the tears out,
ve on and heal. My next tattoos are going to be a modern twist on the classic
ssian dolls, one of each of the front of my things.

ht bicep and lower back Robb at Eternal Tattoos I **Stomach, left and right**
t Ian Saunders doing a sitting at Magnum Opus I **Upper back** Becs at Bespoke

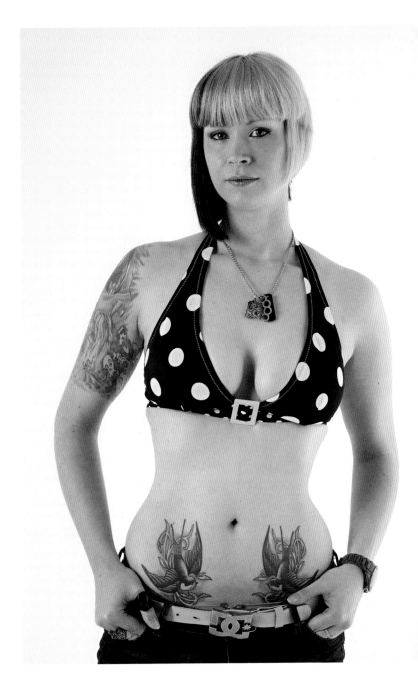

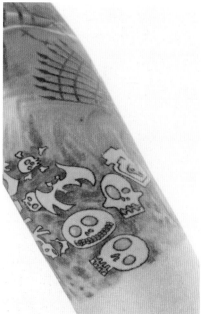

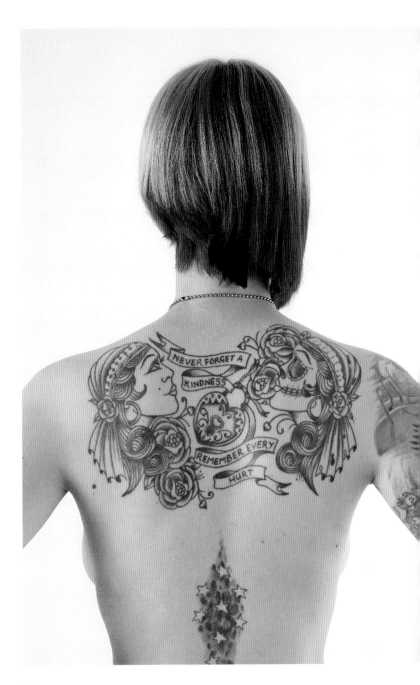

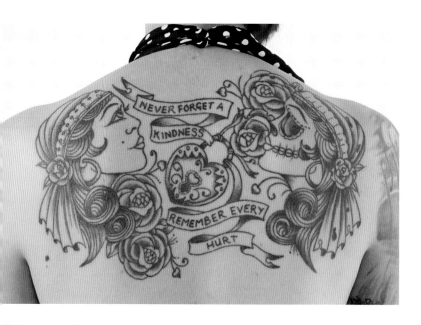

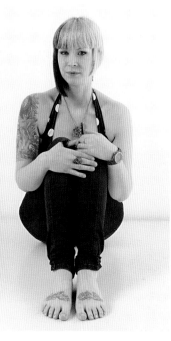

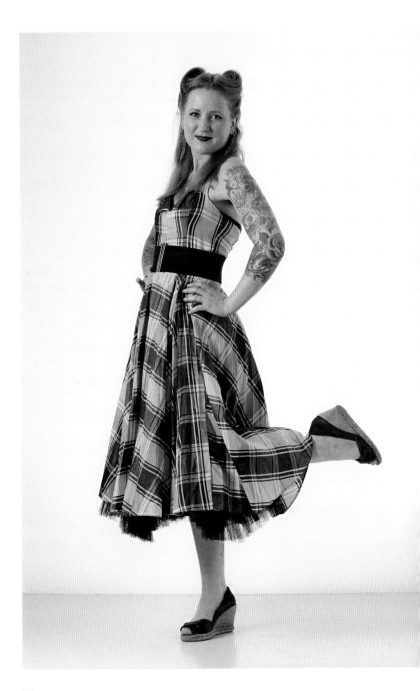

Miss Belinda

Age: 32

I was 18 when I got my first tattoo. I didn't get my next tattoo until about five years later in London because of world travelling and other financial commitments that had stood in the way until then. I like to choose beautiful things to be inked onto my body. They don't always have a special or personal meaning, they may just be things I like. I don't believe it is necessary for them to have meaning. I see my tattoos as more of an art form on my body and therefore I do research to find the artist who I believe will best represent the image I want on my body. I like the way my body looks with all the beautiful bright colours as I believe it reflects my personality. But also it is rather strange, in a pleasing way, to see old photographs of myself with un-inked skin…and how my outer shell has changed. In my work and social life I find my tattoos are a great icebreaker. Next I need to finish the Japanese-style fox by Alex 'Holy Fox' Reinke, which is being tattooed on my left thigh. After that perhaps the back of my left calf to balance out the right one which will probably be some kind of bird, but I have to wait for the inspiration to come first. I love the idea of becoming a forest of animals and flowers.

Left forearm, chest Claudia De Sabe I **Right forearm, left calf, right calf** Diego Azaldegui I **Left thigh** Alex Reinke

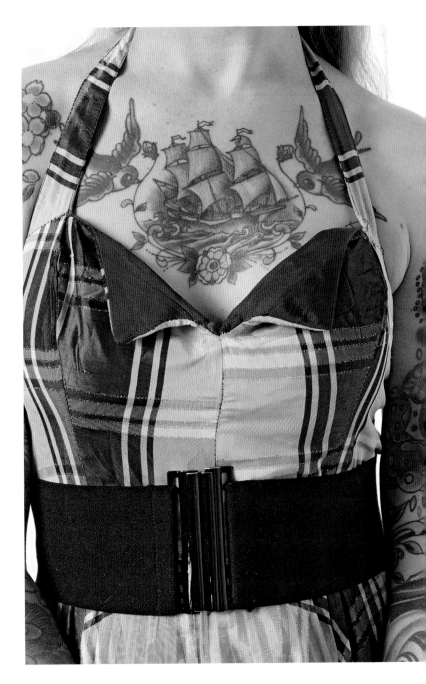

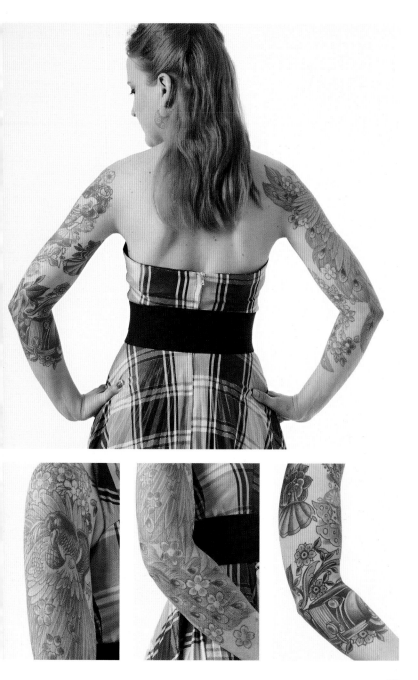

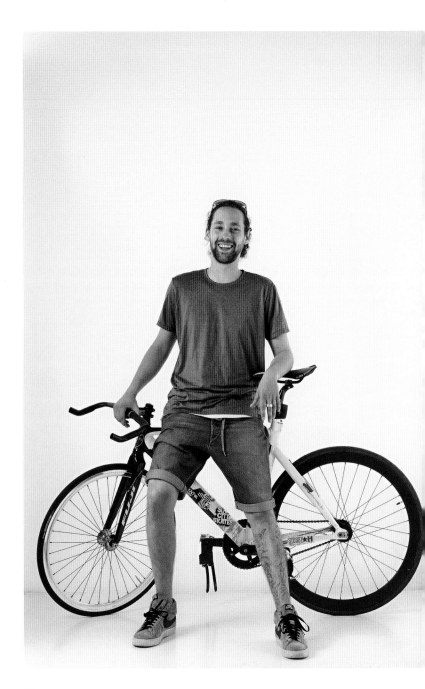

Laylay

Age: 30

All my tattoos represent a place in time, stamped on my body by my good bro Mr Charlie Shazer. I think my next tattoo will be my rib cage, or maybe more on my thigh…we'll see! And it will be a water/wind/flowers/swirls/clouds kind of pattern signed by Mr Shazer!

chest, left thigh, left and right calf, left foot Charlie Shazer

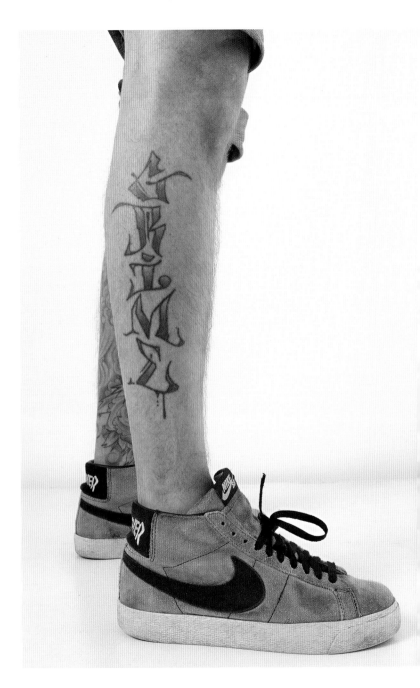

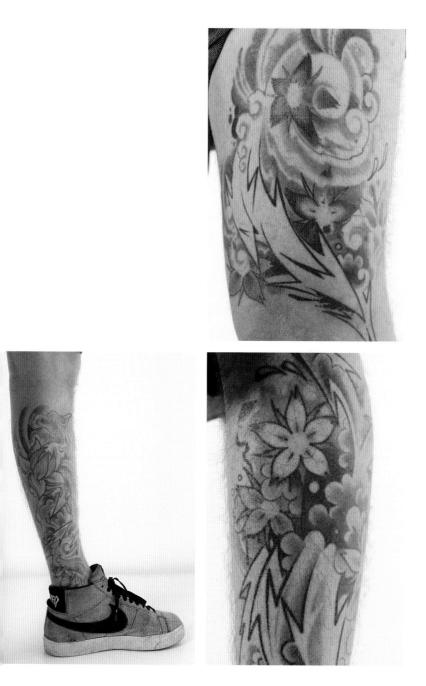

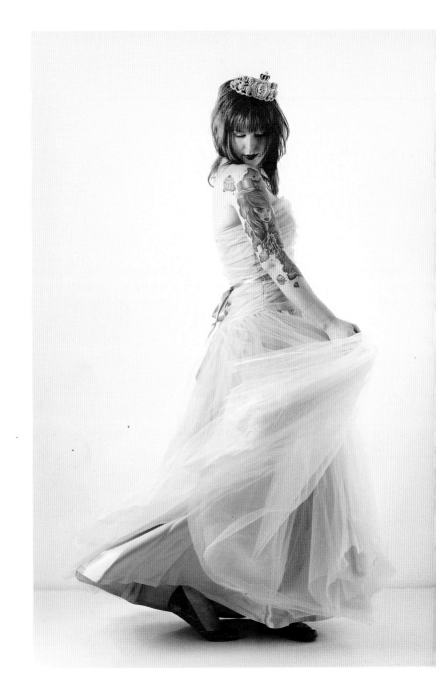

Kat Williams

Age: 26

I'm one of those spontaneous types, and while all of my tattoos remind me of certain times or people in my life, I wouldn't say they had any deep meanings particularly. For example, my best friend and I both got the stars (on my left shoulder) done when we finished Uni to commemorate our love for each other! I also have some writing on my ankle for my husband (it's the meanings of our names in Latin.) My sleeve was obviously the biggest tattoo I got. I've loved sleeves on women for as long as I can remember and had been dying to have one myself for the past few years, and even more so since I started my business blogging about alternative weddings.... I was always looking at beautiful tattooed brides and it just spurred me on even more! I wanted the tattoo to represent the things I love. Again, nothing too deep, but it was important that it was brightly coloured, pretty and girly. The name of my blog is 'Rock 'n' Roll Bride' hence the rock 'n' roll writing. My sleeve is a big representation of me and my state of mind really. I'm constantly thinking about new ink. It's a bit of an obsession. I really want a tattoo done on the inside of my left bicep, but I'm being a wimp about the pain! And I also wouldn't be adverse to getting a tattoo of my two cats.... I love them THAT much!

Right bicep Mike (Mikeowl) Harris I **Upper back** Some random in Camden (whoops!) I **Lower back** Ian's of Reading

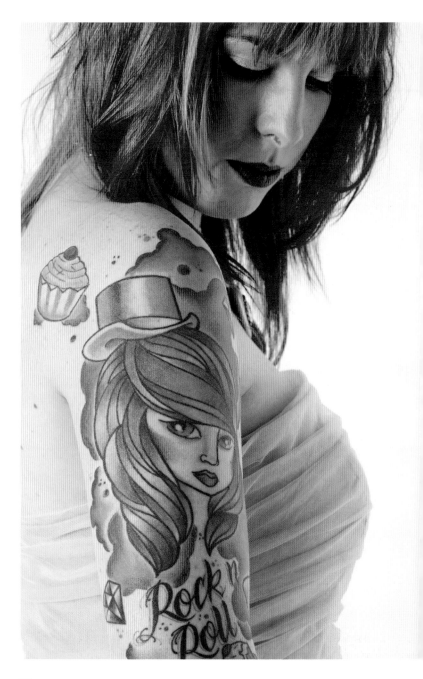

I am obsessed
with photography
(the roll of film),
and love crowns,
bows and cupcakes
(who doesn't!).

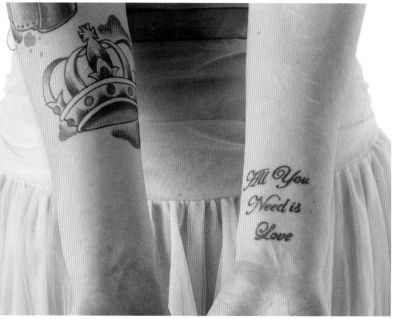

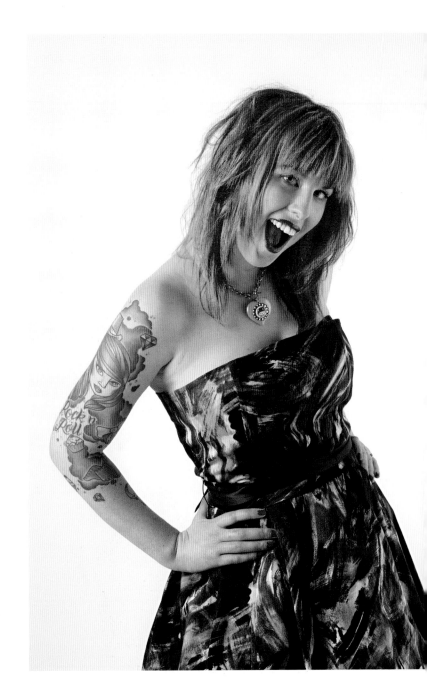

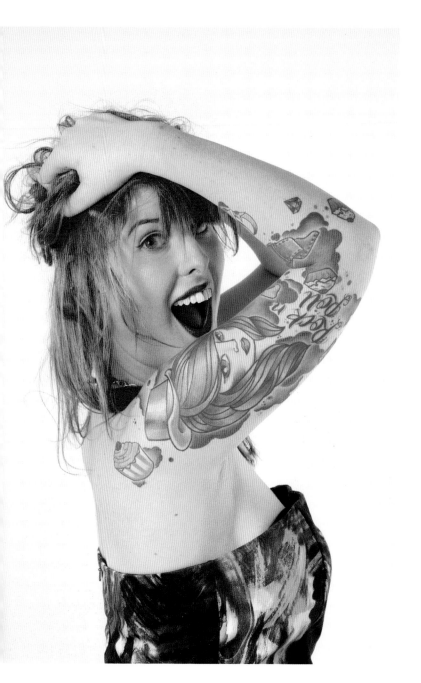

Stewart O'Callaghan

ge: 23

or me, my tattoos are just an extension of my personal aesthetic and humour. eople often ask for the reasons behind my choices, expecting some drawn-out tory or personal philosophy. But for the majority, what you see is what you get. ure, some of them carry a personal meaning, but it's not immediately obvious nd that's how they remain personal. My largest tattoo is a testament to this. designed it simply to merge together a few of my interests: deer, small birds, ea and custard creams. Nothing more, nothing less. My other tattoos tend o be inspired by British idioms/wordplay, nautical literature and traditional tattoo ulture. I'm planning my next tattoo to be on my knuckles. I've waited a long time o be in a position to get so visibly tattooed, despite wanting to have them done or a fair few years now. The text across them will read TACITURN as it's one of y favourite words phonetically, and its definition also holds some small personal elevance. As for my thumbs, one will definitely carry a Triforce, but I'm still eciding on what to put on the other…

ght bicep Gareth at Physical Poetry I **Left forearm** Adam at Headingley Tattoo Studio I
ght forearm Sam at Headingley Tattoo Studio I **Left and right calves, left and**
ght feet DIY I **Side** Scott Mustapic at Ink vs Steel

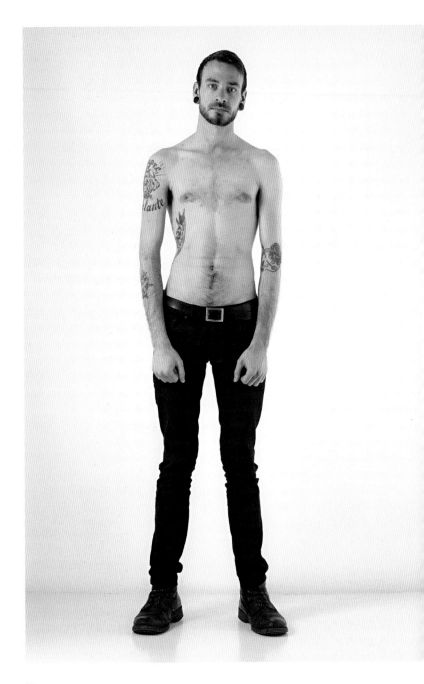

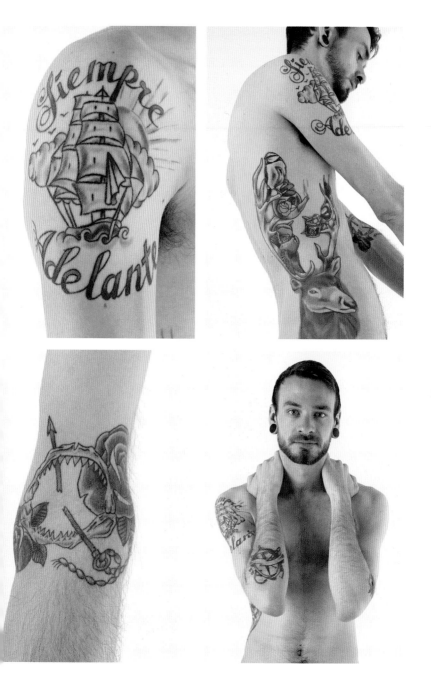

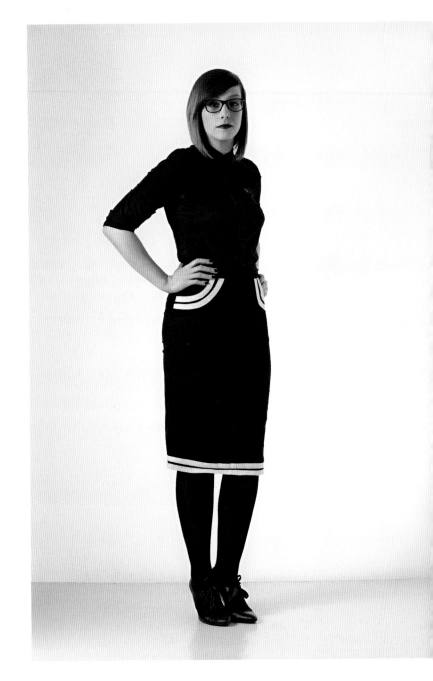

Heather Holyoak

Age: 26

I am a pharmacist and also paint in my spare time, trying to build up a portfolio to become a tattoo apprentice. Many people try to find reasoning and a meaning behind their tattoos, but for me, it was mainly about appreciation of tattoo art. A few of my tattoos do have a deeper meaning to me: the pin-up pharmacist is reflective of my profession; or the lily on my thigh which was my grandmother's favourite flower. But the majority of them are solely because I love the images. I have a slight obsession with owls, and consequently I have several tattooed on me. Working in a professional environment has restricted the level to which I can be tattooed, but I would hope that people can see through them and realise that I am a very good pharmacist and regardless of being tattooed or not, my advice would be the same. Next, I would like to get more of my left arm done by Todd Noble. I am really excited to see what else he can come up with.

Left bicep Todd Noble, USA | **Right bicep** Seth Wood (owl) and Bailey Hunter Robinson (bird), both New York | **Chest** Guen Douglas at 25 To Life Tattoos, Rotterdam | **Left thigh** Phil Kyle at Magnum Opus, Brighton | **Right thigh and left and right feet** Jamie Skdale, Bromley | **Left and right calves** Rose and Bob Done at Magnum Opus, Brighton | **Right ankle** Hunter Spanks, USA (anchor) | **Left ankle** Jack Newton at Angelic Hell, Brighton (owl) | **Right leg** Luci Lou at Magnum Opus, Brighton (small owl)

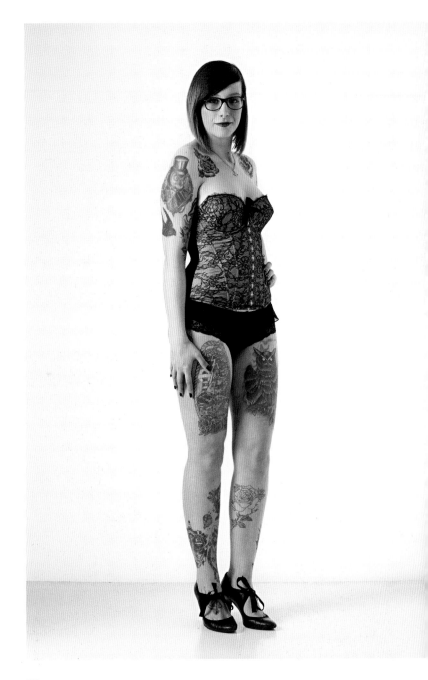

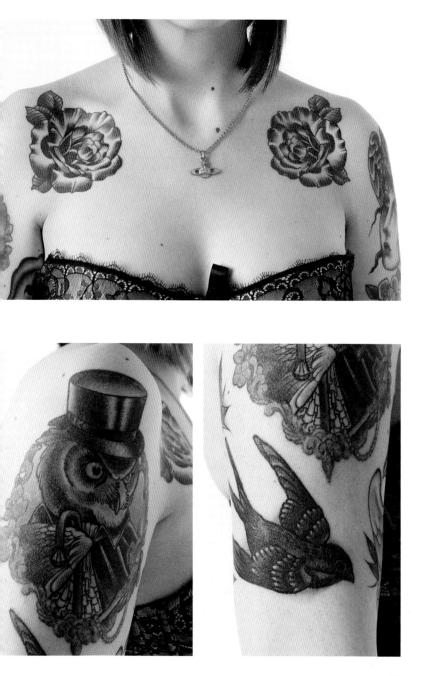

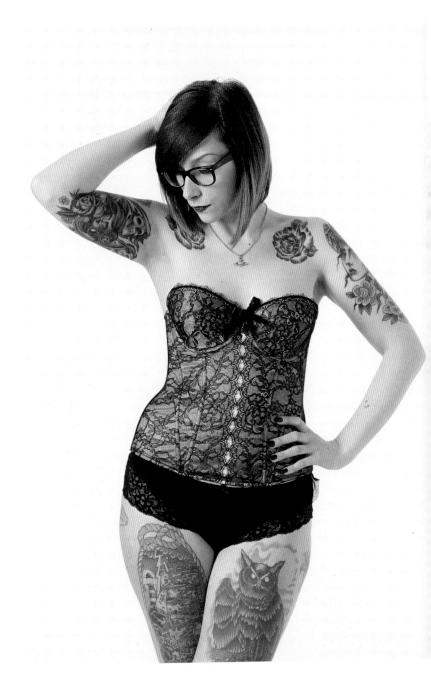

o me, my tattoos
re more than skin deep:
hey represent
vho I am and I would be
othing without them.

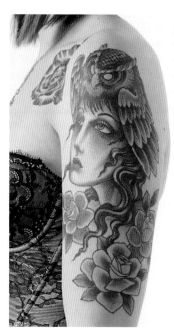

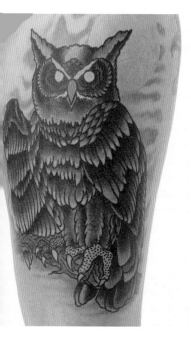

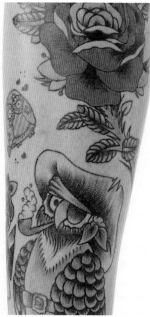

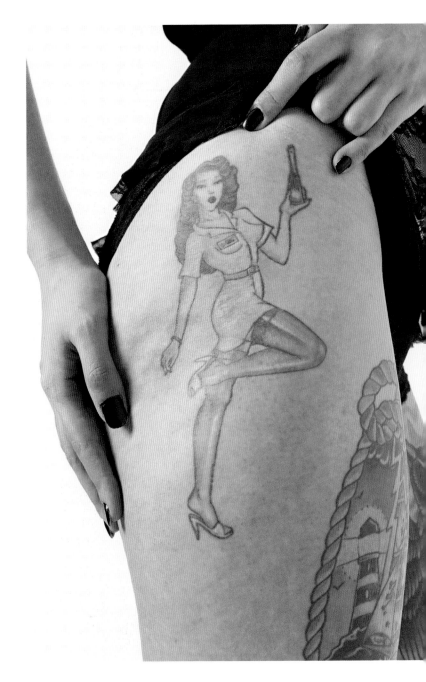

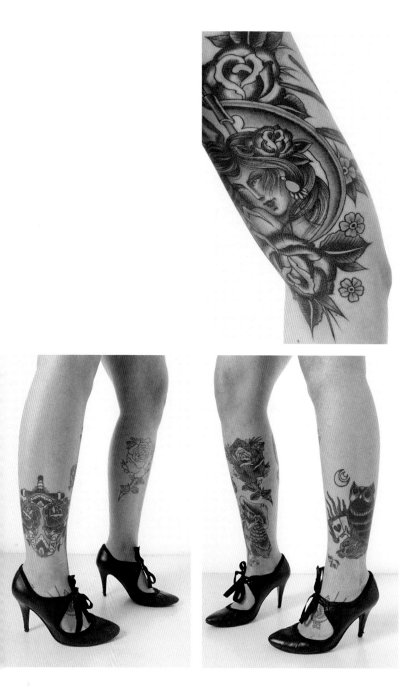

Scott Pollard

ge: 38

vas on holiday in Mallorca and walked past a tattoo studio every day coming back
om the beach. The studio appealed to me as it was always swarming with locals,
d was not designed to attract tourists. It had house music banging out at all
ours (which is totally out of character for this small port in Pollensa!) and always
d people milling in and out, chilling together with a cold beer outside. Before
vent home I decided I had to go in. In a kind of 'Trainspotting' style, I spent the
xt couple of hours trying to cross the language barrier, while being worked on to
e happy house music. I left the studio exhilarated with a sun tattooed between my
oulder blades — sorted! I loved my first tattoo, and this started me off wanting
ore, something creative and something I could see more of — time for a sleeve!
spent many hours researching different artists and styles of work to plan for the
xt design. It took a year to find my artist but was well worth the wait. James's
sign and style of work is exactly what I wanted. My passion for the sun, sea and
rf is caught perfectly and flows between the Oasis lyrics 'Now that you're mine,
find a way of chasing the sun, let me be the one that shines with you', which
es out to my kids. My latest tattoo is almost complete — just one session left to
ish off some shading and a little colour. It expresses my love of music and its
ity with my soul.

per back Joan at Mi Vida Loca, Pollensa, Mallorca I **Right bicep and
earm** James Robinson at Nine, Brighton

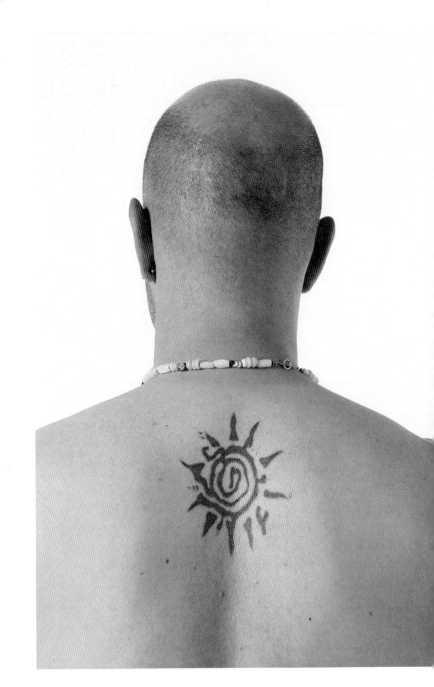

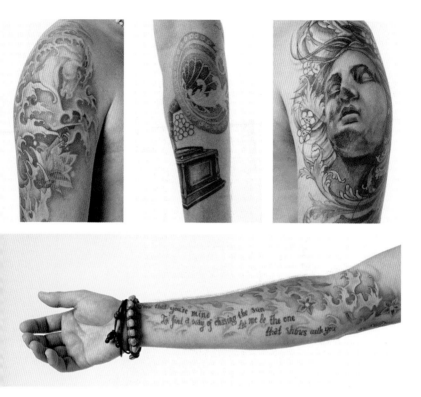

All my tattoos express the things in
my life that I'm passionate about:
the sun, the beach, my family and music.

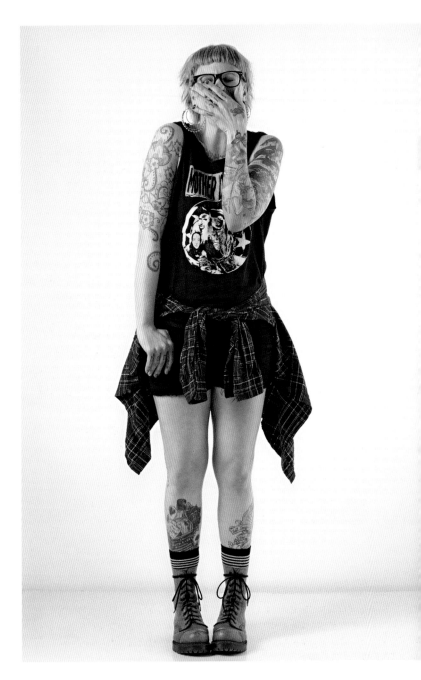

Louise Elizabeth Fury

Age: 33

As a whole, my tattoos don't really 'mean' anything. I don't use them to mark 'milestones' or as 'expressions of my individuality' (I couldn't even type that without laughing). Some of my tattoos are symbolic and/or blatant representations of something, like emotion or in some case actual words expressing these things. Some are just things I like. I like dinosaurs and thought that T-Rex would be amazing. I try to make some of the real meanings behind them subtle, like the bottle of Black Label on my shin isn't a 'Yay! I LOVE booze' tattoo (even though it looks like it!), because of the note on it that says 'You're better than the world you live in'. Most people don't see the note and to be honest, I like it better that way. I know what they all mean. I don't need other people to understand them all. I also get really annoyed when people say they are 'addictive'. It makes it sound like an excuse for doing something bad or wrong. It totally cheapens it. My next appointment is to finish the roses and the Victrola on the outside of my left lower leg, get the inside lined with a teapot and tea cups, and discuss a large thigh piece of a wolf in sheep's clothing. It's going to be a bit bloody and gory but also girly. I want to push that one ahead and start it NOW!

Left bicep and forearm, chest, right calf, both shins, right rib/side Guy Tinsley I Right bicep and forearm Henry Hate I Left and right hand Adam Lewis I Hand tattoo Unknown artist (way too old and crappy to care) I Ribs (writing both sides, under breasts) Simon Earl

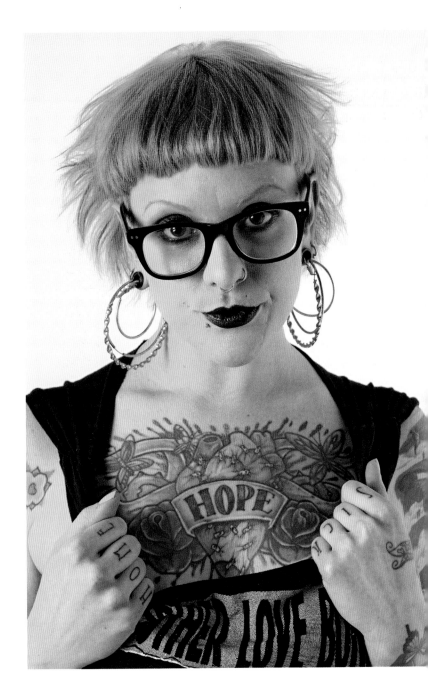

I don't 'justify' my reasons for getting
tattooed by saying
'Oh, it's for that or about this…'.
I just do it.

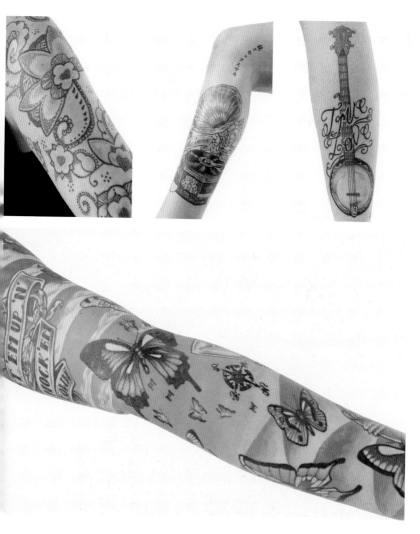

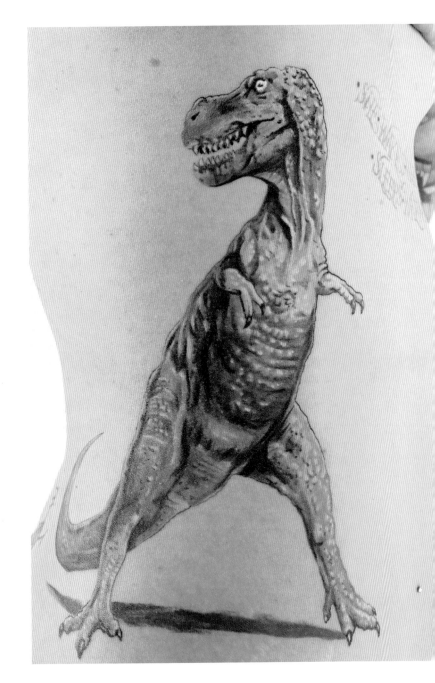

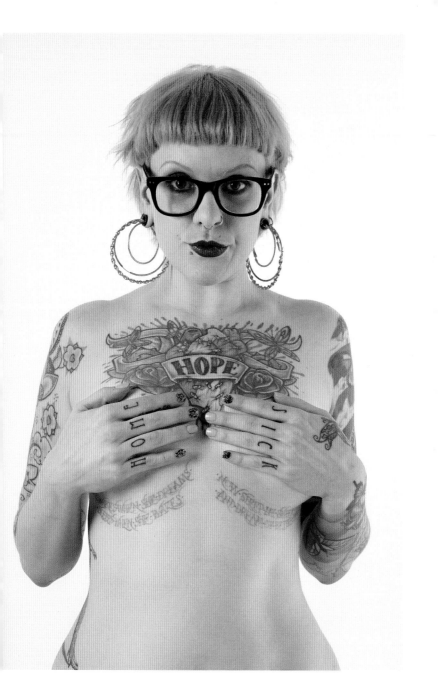

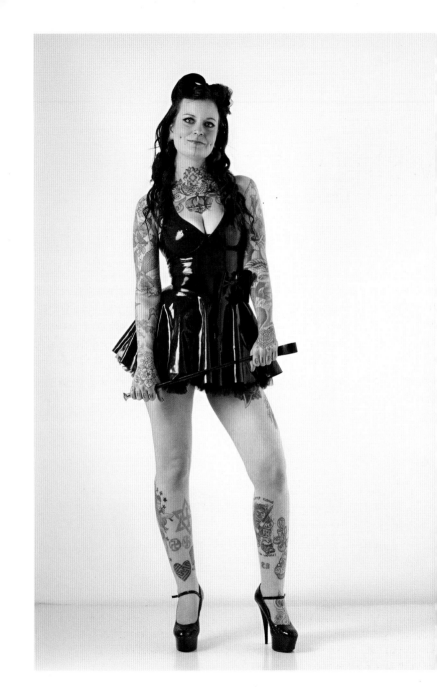

Mistress Jezabel

ge: 28

ome of my tattoos mean nothing, some mean a lot. The ones that mean the most
ɔ me personally are the ones done by my friends. They may not be the best
rtistically but they are done with love and that's important. I have lots of different
tyles of tattoo on my body, but I like being a bit random — it fits with my personality.
have several ongoing projects, and am sorting my left arm out (it's being blacked in).
ʼly right thigh is having various things done to it, and then off to Belgium for more
lack work and a cover-up project for my back piece. I am always planning new
ɒpointments, there just never seems to be enough hours in the day!

lead Xed Le Head I **Right and left neck, right and left hand** Dan Dimattia I **Right
icep and right forearm** Jo Harrison I **Chest, stomach, upper and lower back**
arious I **Left thigh** Alejo Lombardi I **Left calf** Rachel Macarthy I **Right calf** Mad
lan I **Left foot** Boff Konkerz

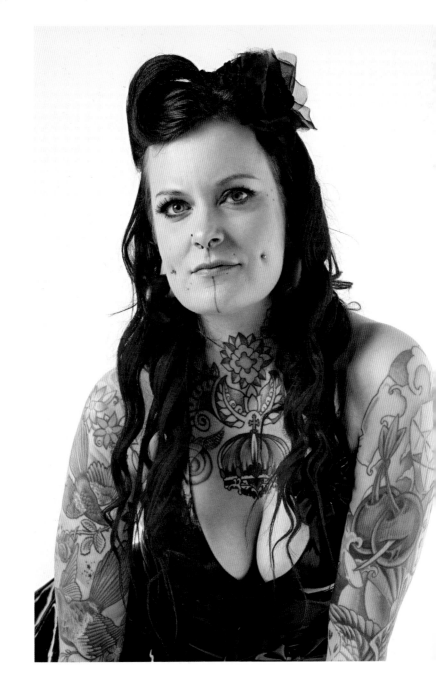

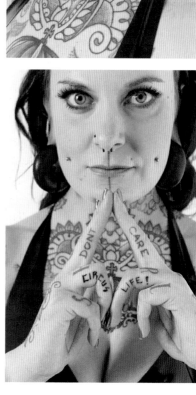

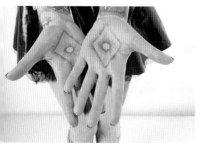

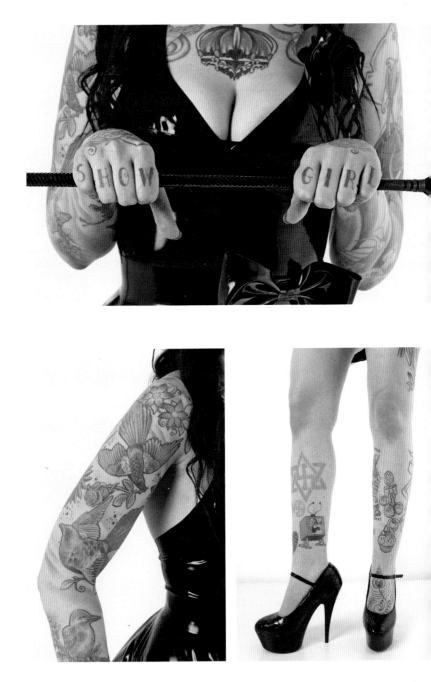

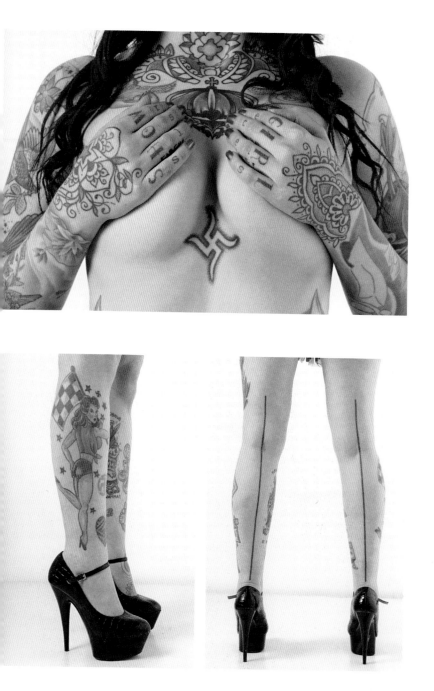

Acknowledgements

I would like to thank everyone who made this book possible.

Thank you to Robert Radmall, for endlessly toting heavy equipment with me, for weeks of perseverance and above all, for your invaluable lighting advice. Thank you to Corrine, for a wonderful job with hair and make-up, for putting our subjects at their ease, and making them comfortable before the shoots. Thank you to Paul Walsh at Direct Photographic London for your advice with organizing lighting rental. Thank you to Tom Gilbert Scott for building the London Tattoos website, and taking my calls late at night.

Thank you to my publishers, Prestel, for your continued support. I would especially like to thank Andrew Hansen, Oliver Barter and Philippa Hurd, who worked back and forth with me editing and compiling thousands of photographs. Thank you to Andrea Mogwitz for your beautiful and succinct design work.

This book is dedicated to the people who unveiled their bare bodies so willingly before my lens. Thank you for sharing the art imprinted on your skin, and the histories that make up your lives, for allowing me to capture years of work and endurance sealed in one photographic moment. This book stands not just as a document of the tattoo artists' work, but of your experiences, hopes and even your regrets.

It is through the chronicle of the tattooed body that we better understand the human experience.

Alex MacNaughton, August 2011

Prestel Verlag, Munich
A member of Verlagsgruppe Random House GmbH

Prestel Verlag
Neumarkter Str. 28
81673 Munich
Tel. +49 (0)89 4136-0
Fax +49 (0)89 4136-2335

www.prestel.de

For more on this book and information on our future Tattoos projects, see
www.londontattoosbook.com

Prestel Publishing Ltd.
4 Bloomsbury Place
London WC1A 2QA
Tel. +44 (0)20 7323-5004
Fax +44 (0)20 7636-8004

Prestel Publishing
900 Broadway, Suite 603
New York, NY 10003
Tel. +1 (212) 995-2720
Fax +1 (212) 995-2733

www.prestel.com

Library of Congress Control Number: 2011929013

British Library Cataloguing-in-Publication Data: a catalogue record for this book is available from the British Library; Deutsche Nationalbibliothek holds a record of this publication in the Deutsche Nationalbibliografie; detailed bibliographical data can be found under: http://dnb.d-nb.de

Prestel books are available worldwide. Please contact your nearest bookseller or one of the above addresses for information concerning your local distributor.

Editorial direction: Philippa Hurd
Proof-reading: Ali Gitlow
Production: Friederike Schirge
Art direction: Cilly Klotz
Cover, design and layout: Andrea Mogwitz, Munich
Origination: Reproline Mediateam, Munich
Printing and binding: Printer Trento S.r.l., Trento

Printed in Italy

ISBN 978-3-7913-4584-0

FSC
www.fsc.org
MIX
Papier aus verantwortungsvollen Quellen
FSC® C015829

Verlagsgruppe Random House FSC-DEU-0100
The FSC-certified paper *Hello Fat Matt* has been supplied by Deutsche Papier, Germany.